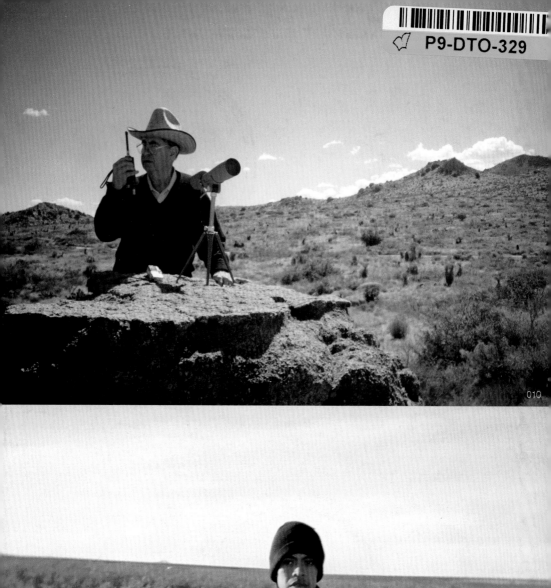

010

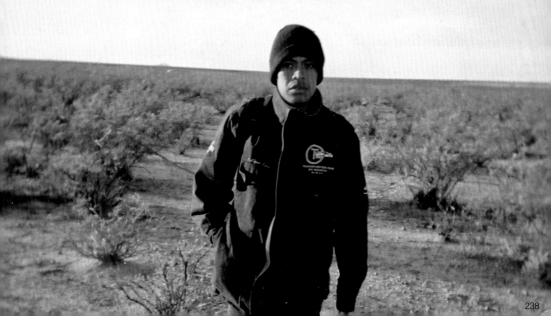

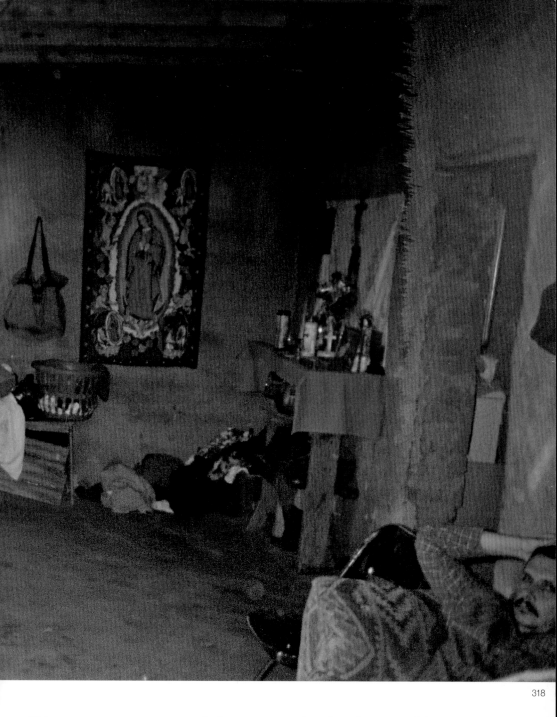

"Here you earn enough for sugar, the basics, nothing more. There, they say, you can earn enough for tomorrow. That's why people migrate. To get ahead."

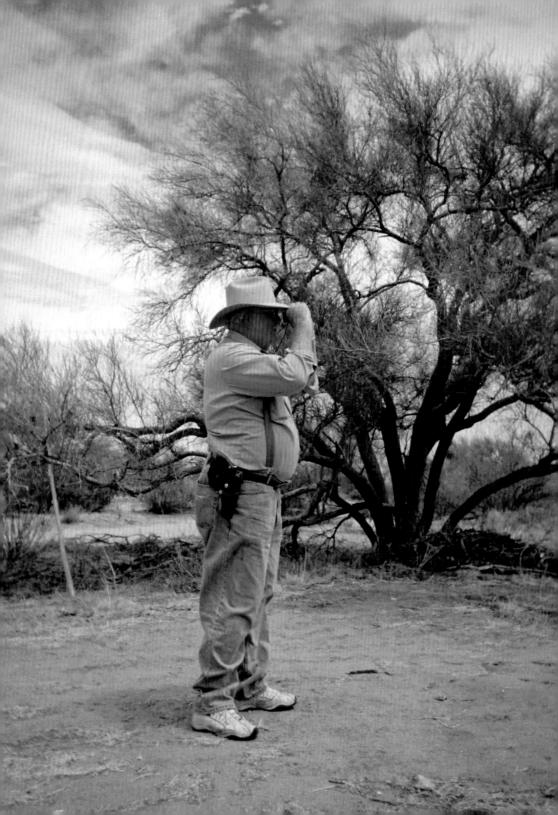

"I think all of us, in our hearts, would say that we would defend our country. And it dawned on me that if I didn't get off my butt, I no longer had the right to claim that."

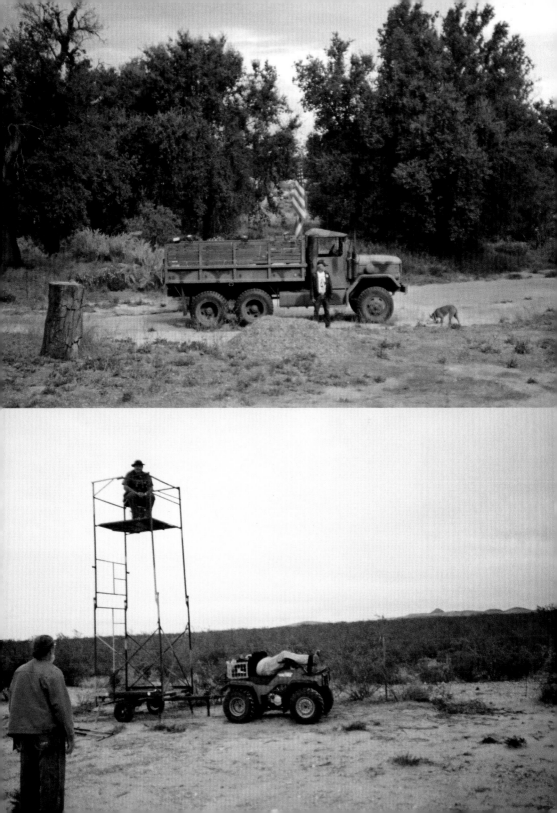

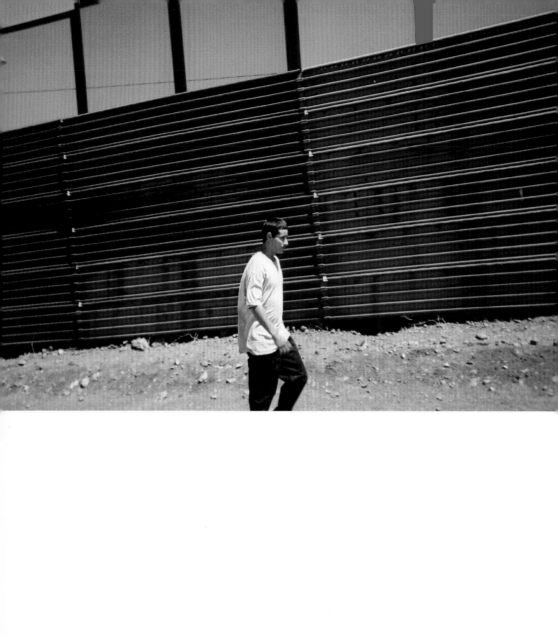

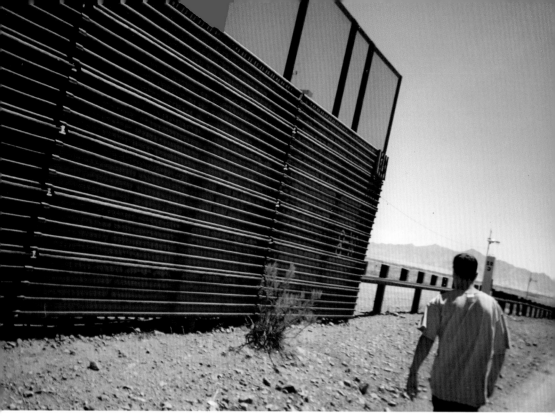

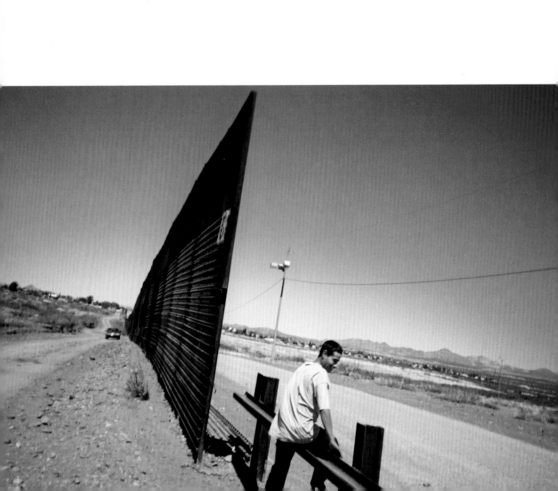

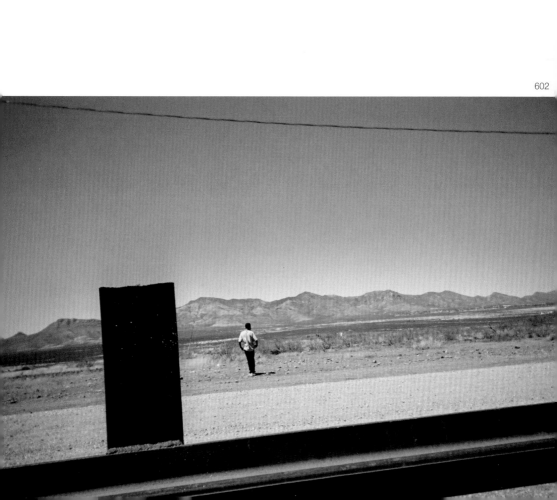

"'Standard Operating Procedure' for spotting and reporting illegal aliens: If you spot them, report them directly to your line boss via radio. Your line boss will call Border Patrol."

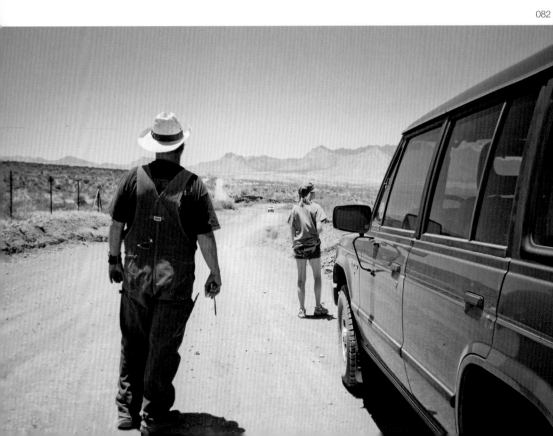

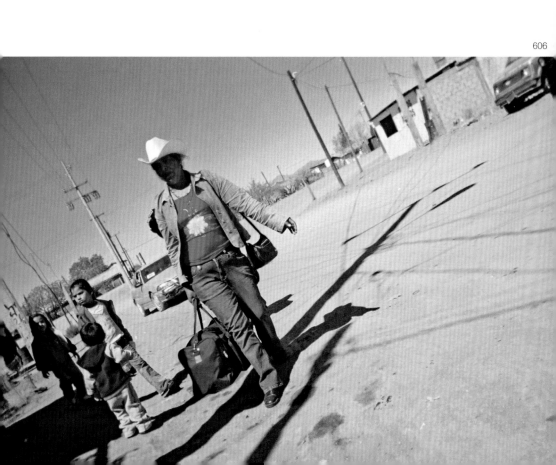

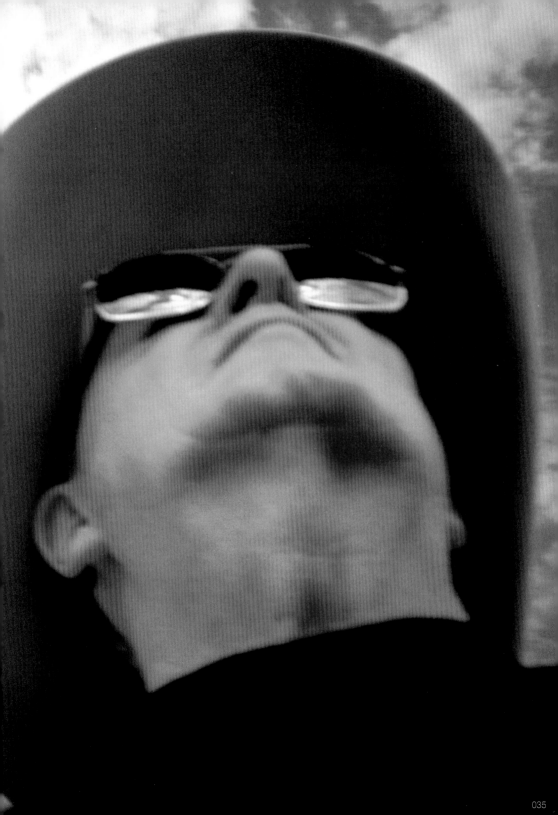

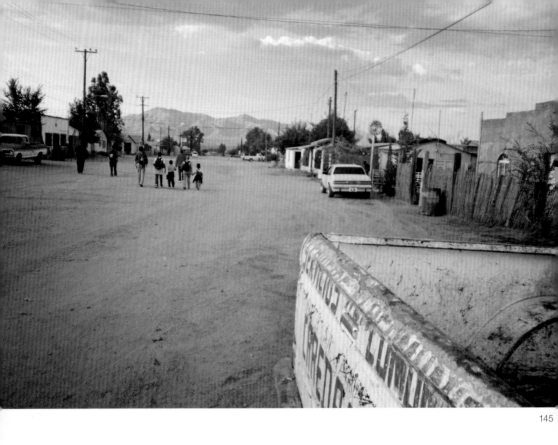

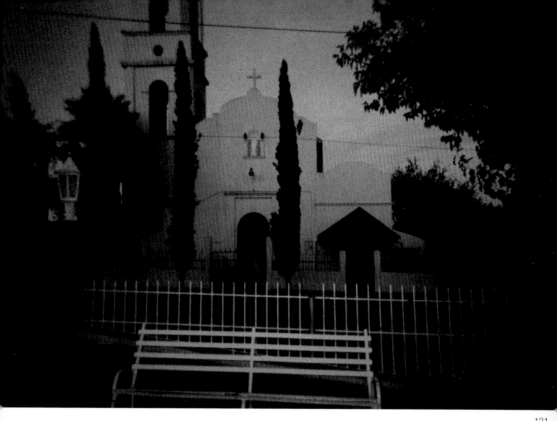

"Our little boy got sick with diabetes. We have to take care of him. We packed food and water, and medicine for the boy. We're in God's hands now."

318

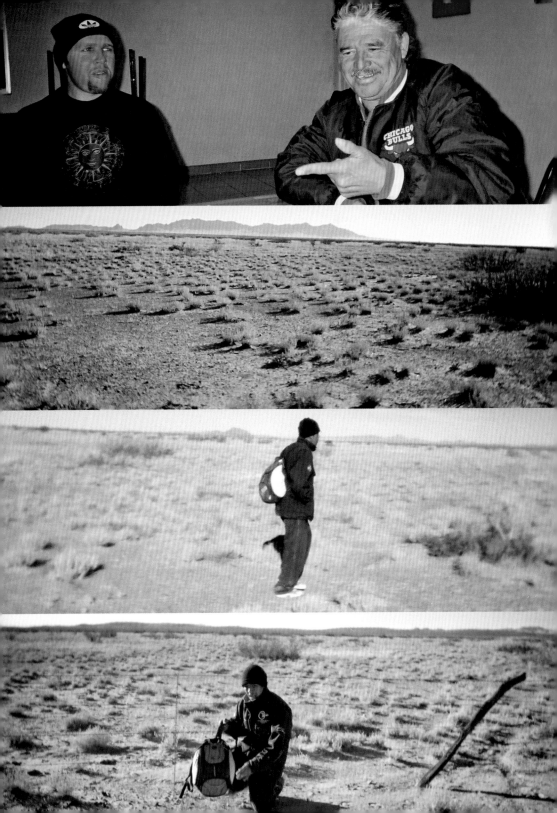

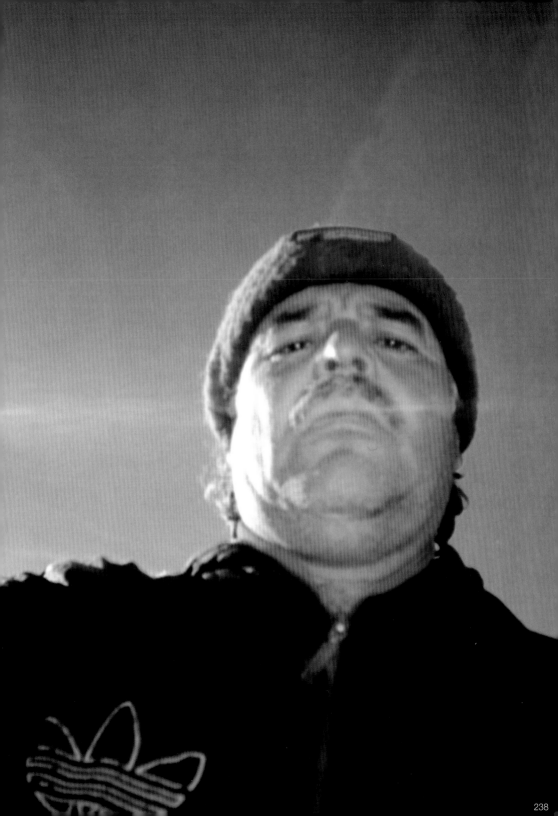

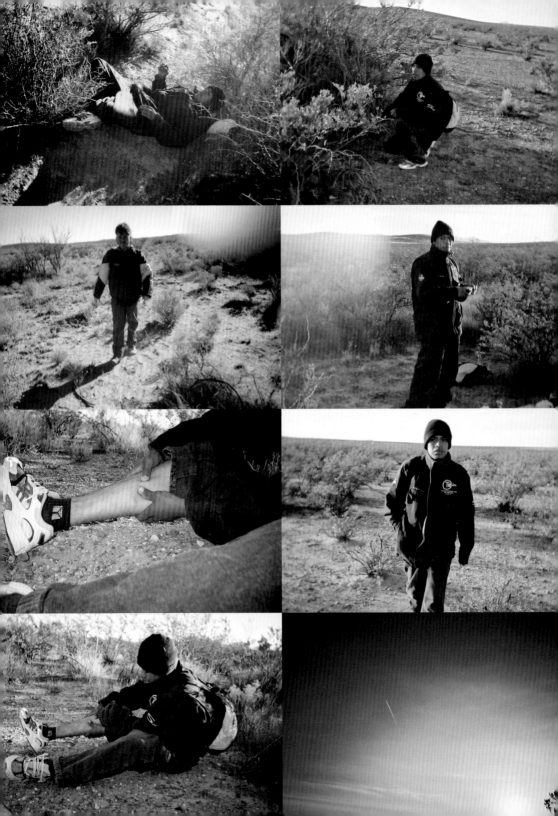

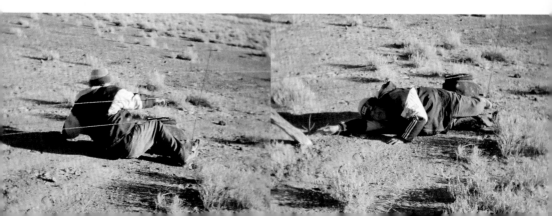

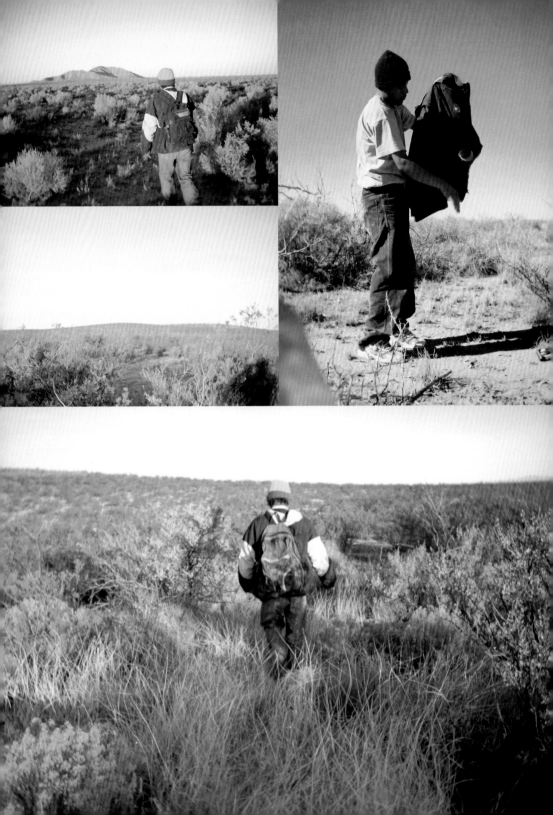

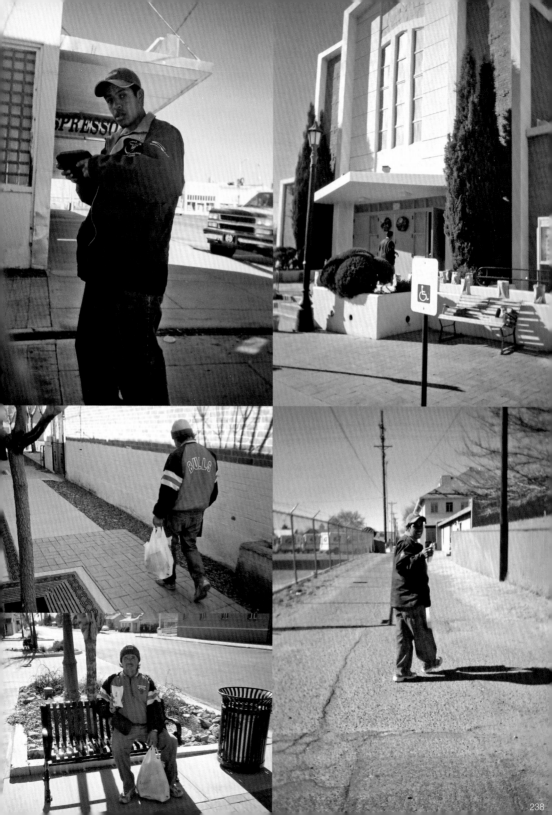

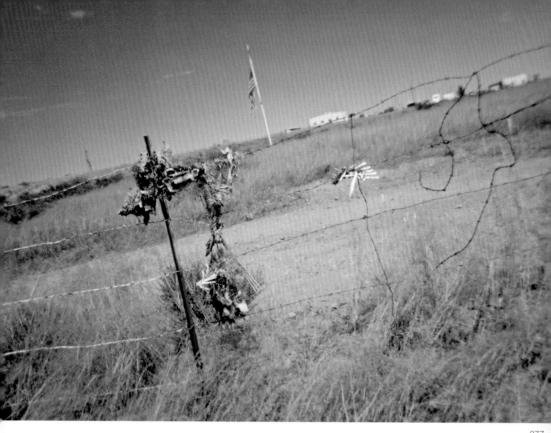

"When I decided to come, I made up my mind.
I was willing to die."

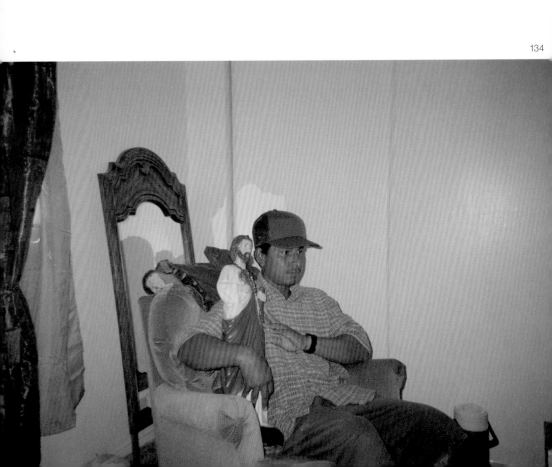

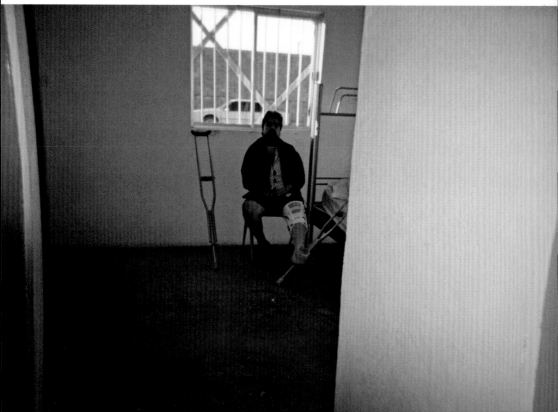

"We're united by common cause. We don't know each other—we don't even have to like each other. But by God, we'll get the job done. Luckily, we like each other."

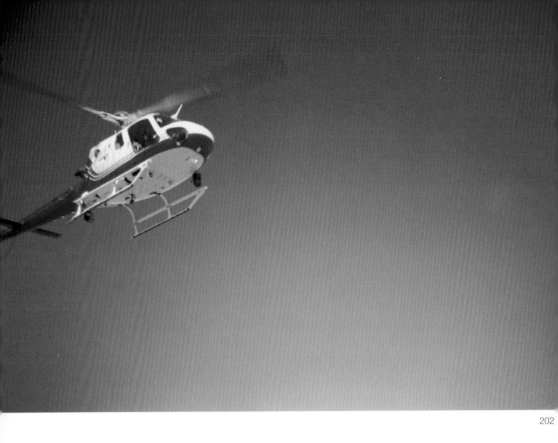

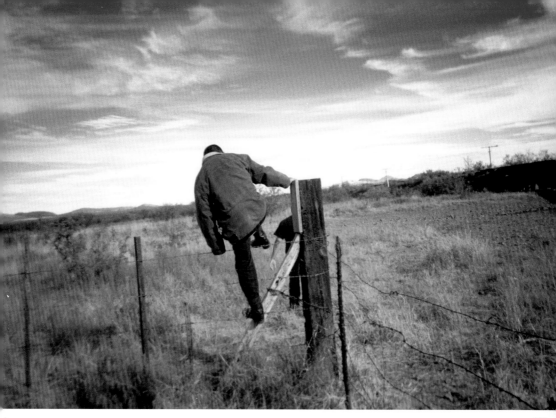

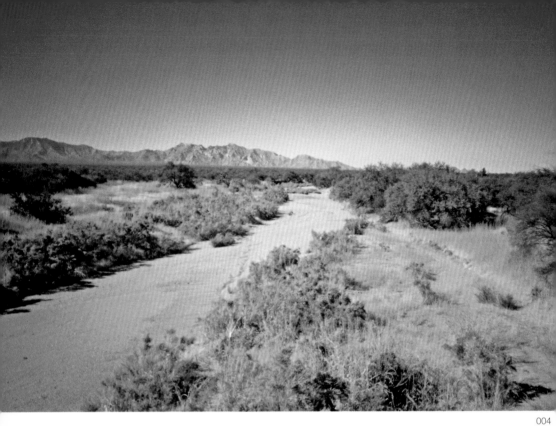

004

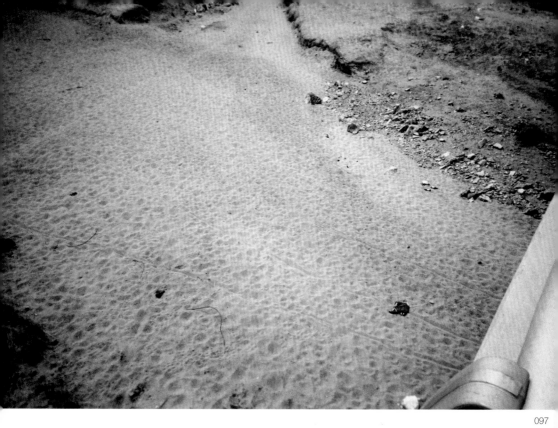

"You see the footprints? That's Grand Central Station all the way to Phoenix."

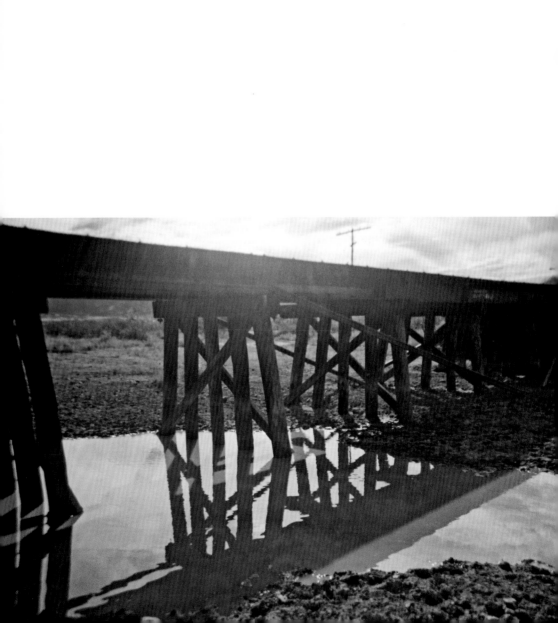

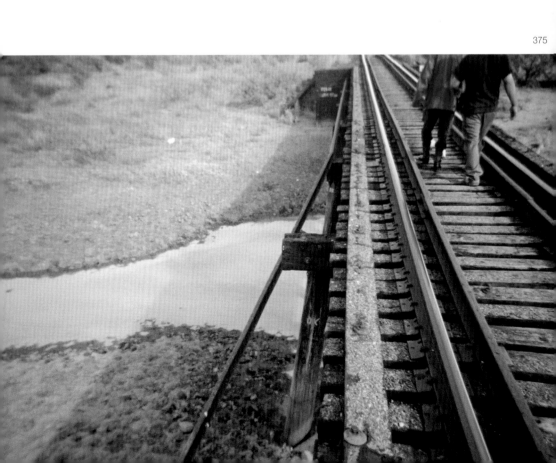

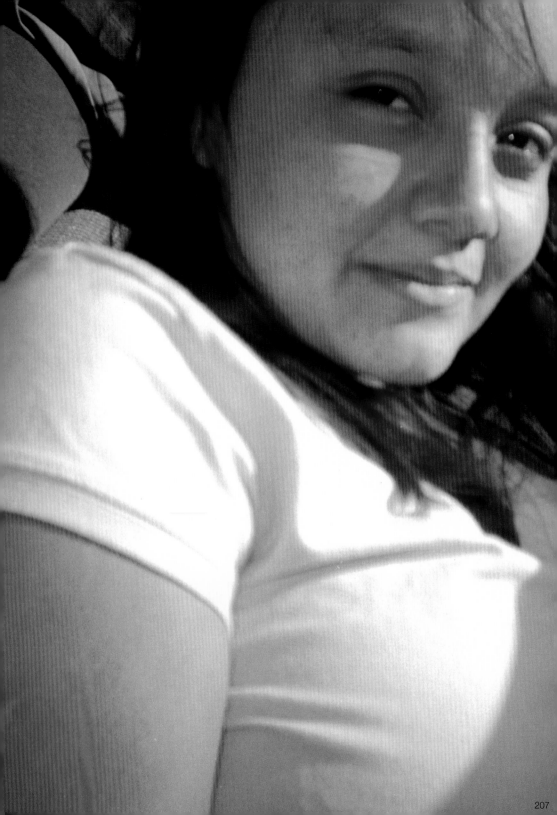

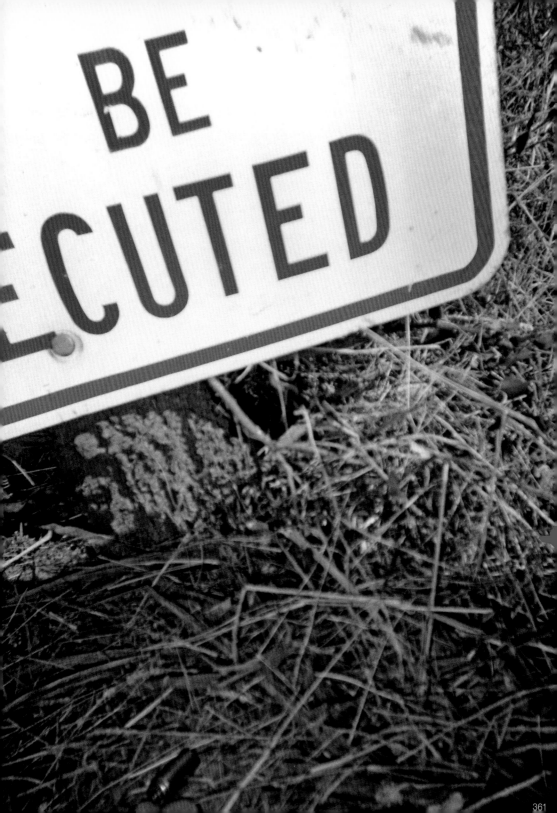

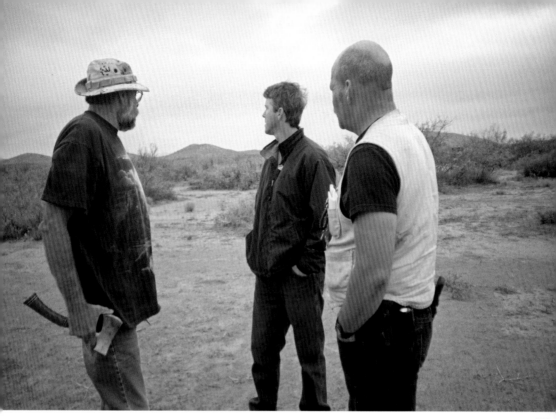

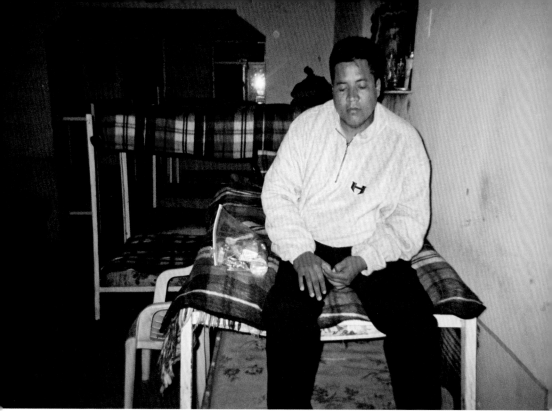

"When we got to the line, they were waiting for us—these guys with face masks. They started touching me, looking for my money, and they found it sewn into my shirt. They stole my water, my food, my money. They sent us off barefoot—without shoes."

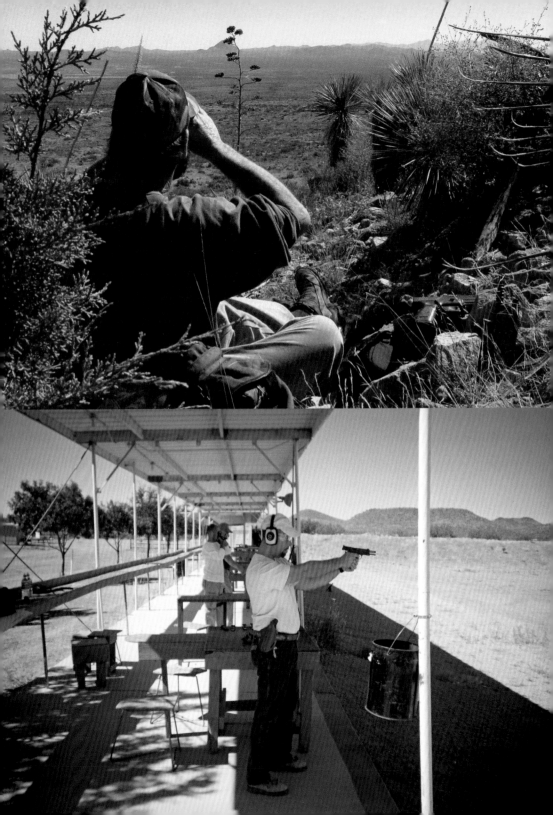

"The biggest import of drugs is speed, heroin, cocaine, and marijuana. Right here at Post 6, we have spotted over five hundred pounds of marijuana with armed security. That is why we are armed: these people will shoot us. They have already vowed to shoot us."

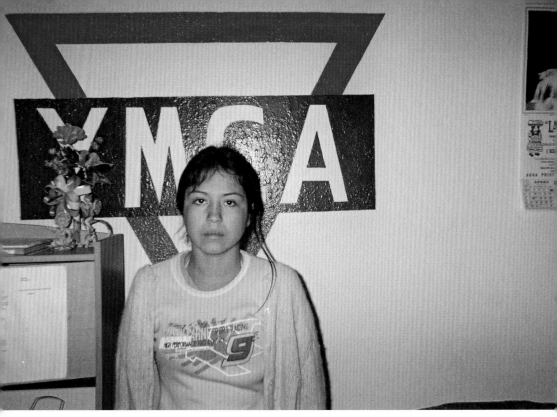

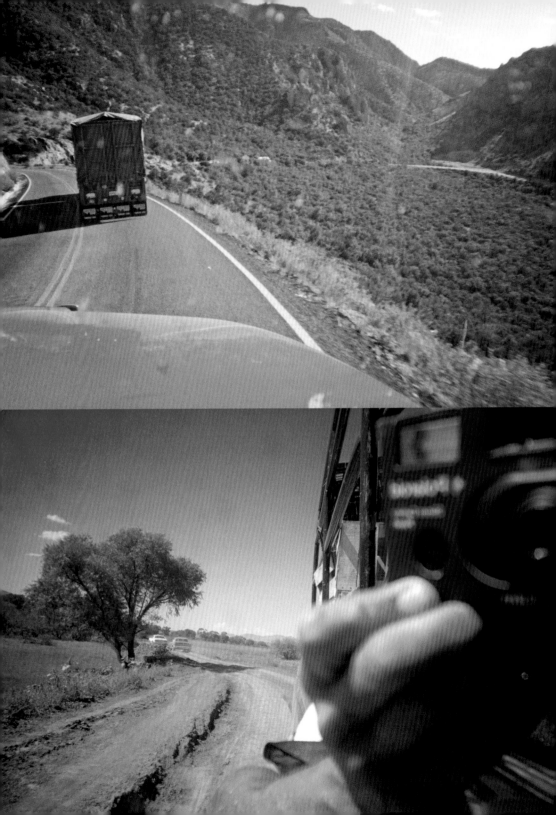

"He told us that he was going to put us only in mini-buses, but when we were halfway, he said, 'Climb in the back of this freight truck.' You're squeezed in there like cargo—like oranges or cabbage."

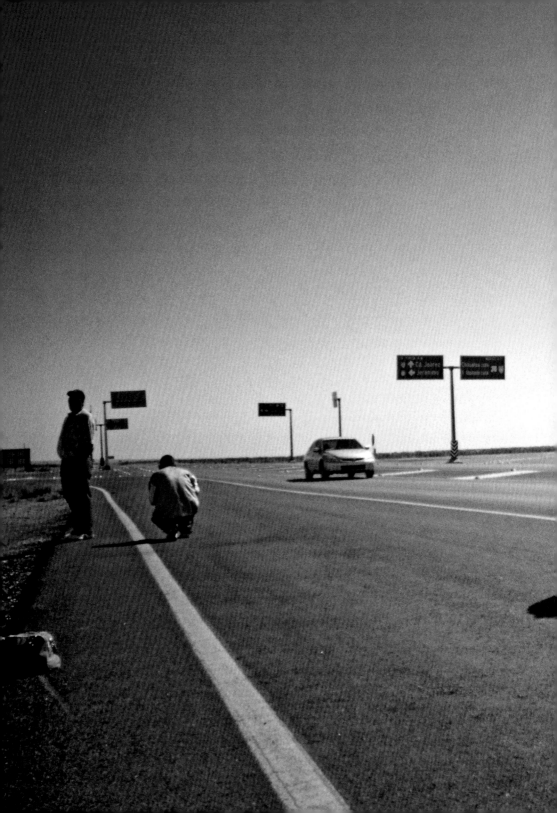

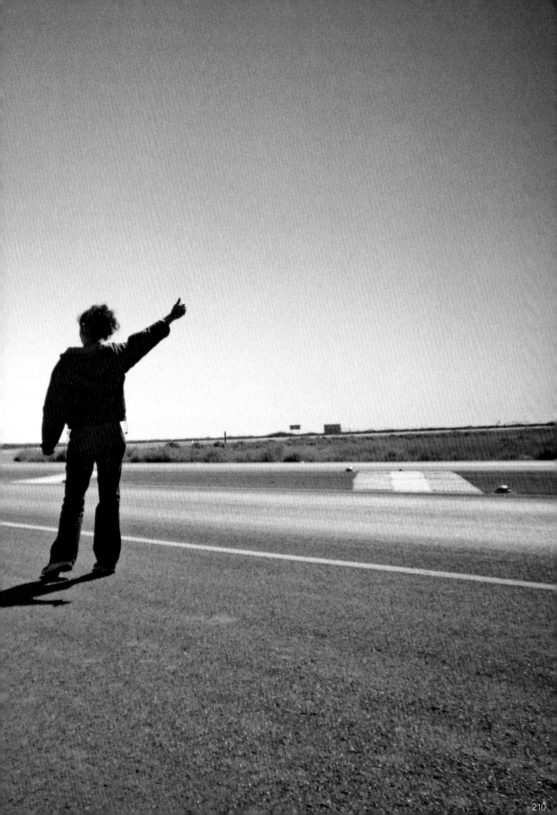

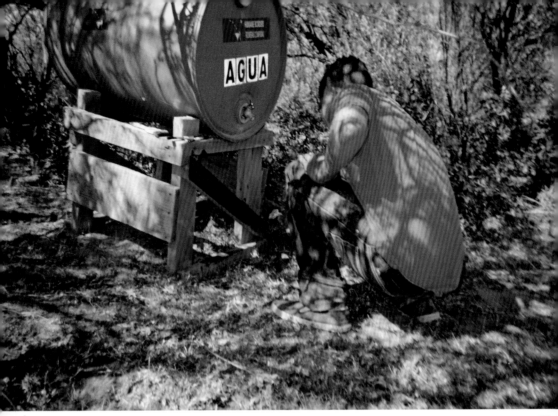

"You can't just drink it and drink it. You have to make it last. When it's gone, you have to survive by drinking from some trough. Or if it rains, from the puddles. Just to wet your lips."

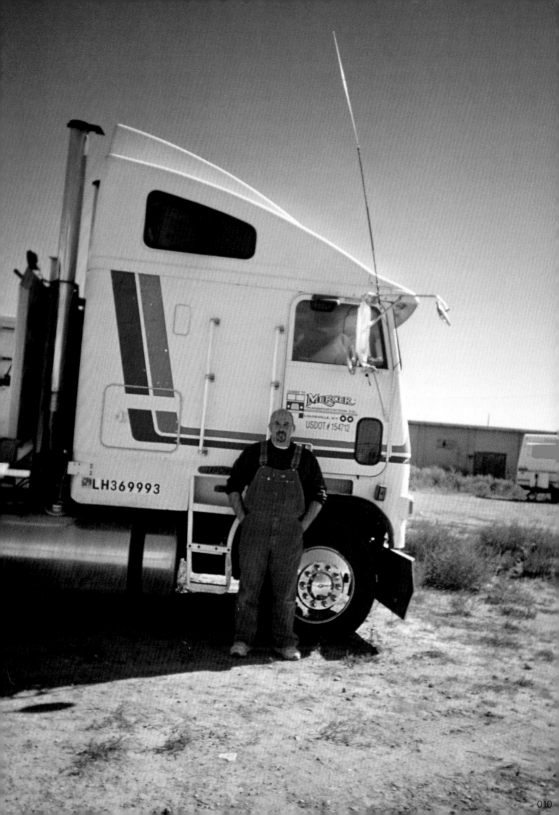

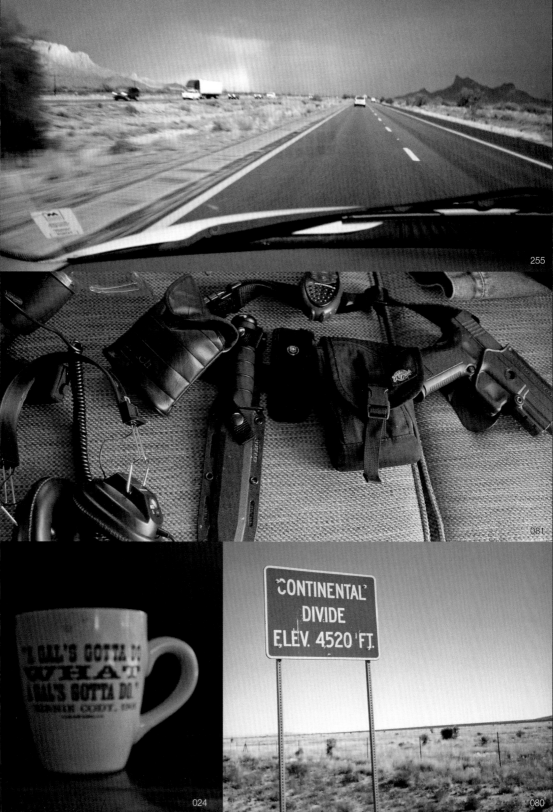

255

081

024

080

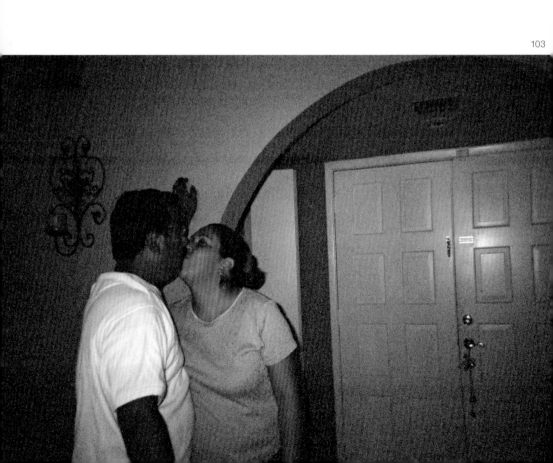

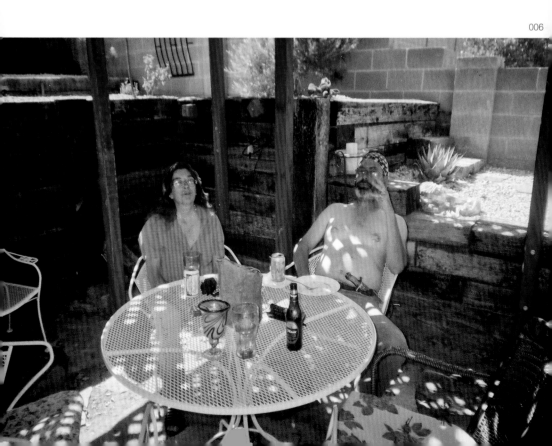

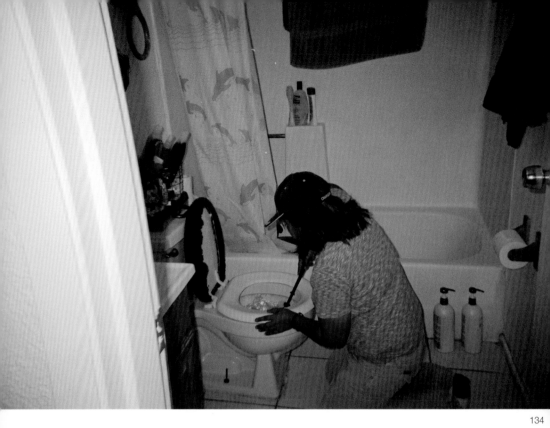

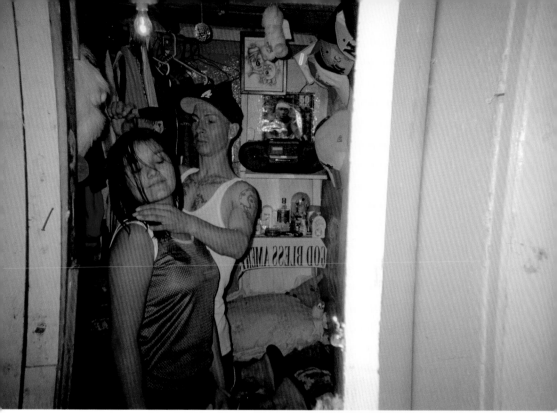

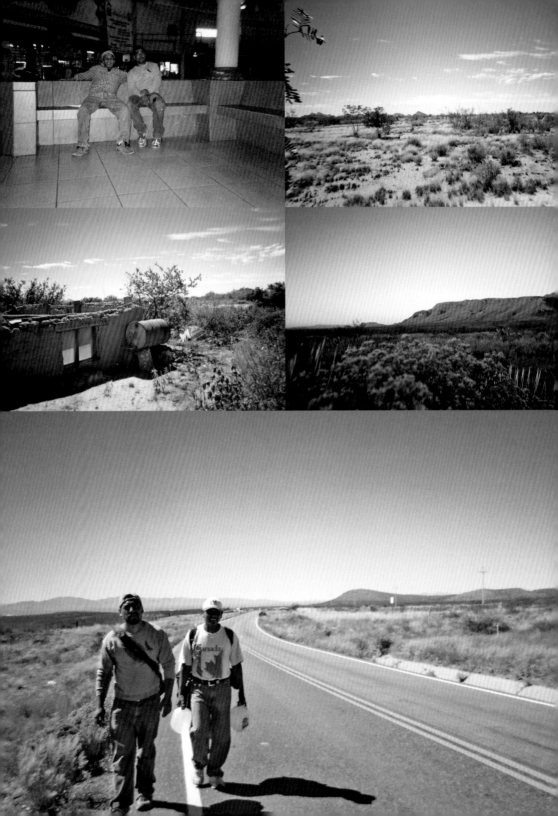

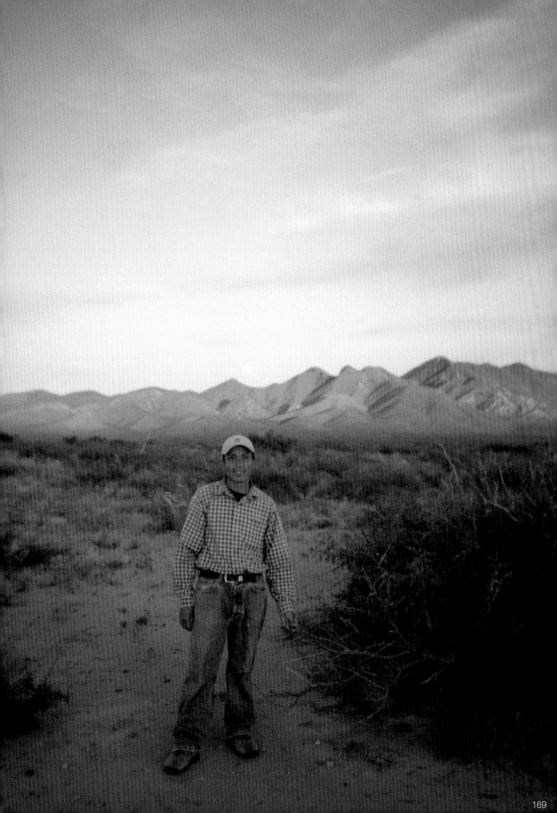

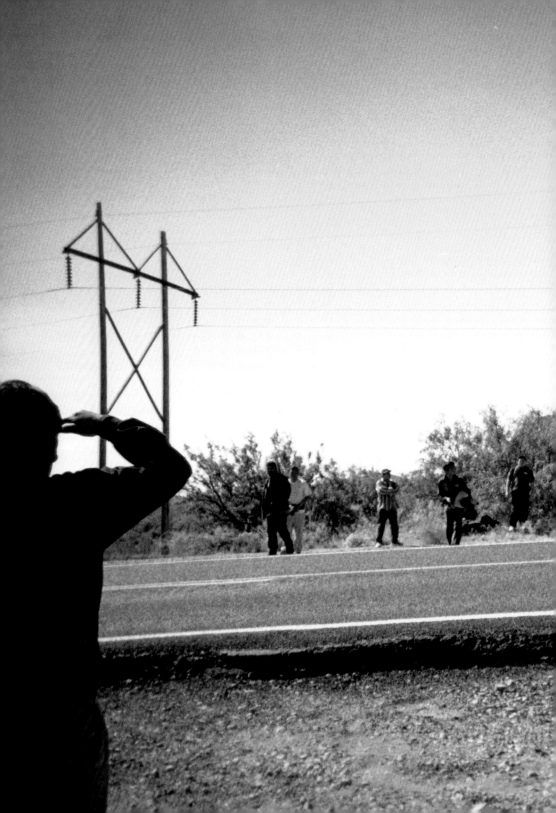

"The driver comes to pick you up and take you to a safe house. If he doesn't get there on time, then you wait in fear that the next truck will be *la migra*."

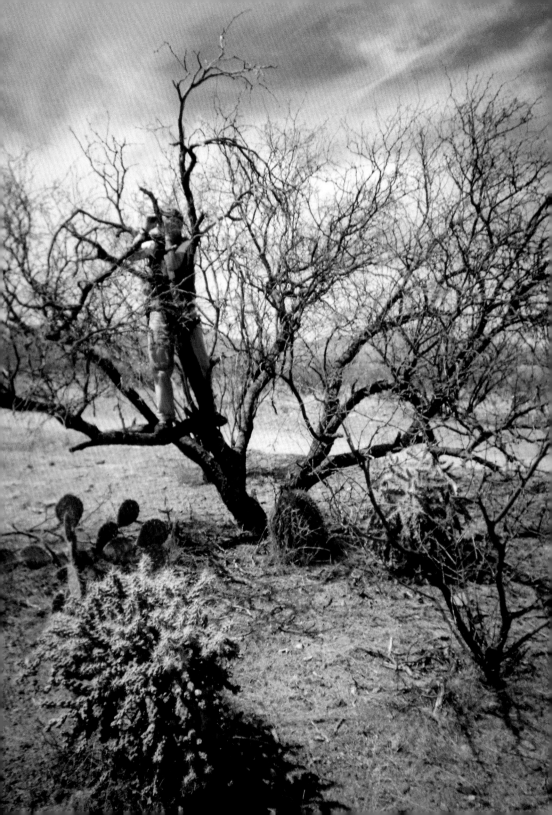

"I worked on a plantain farm in Mexico. I used to earn $45 a week, working twelve-hour days. But if three Central Americans come to work, they only get paid $15 a week. So what does the owner do? He can now employ three men for the price he pays me."

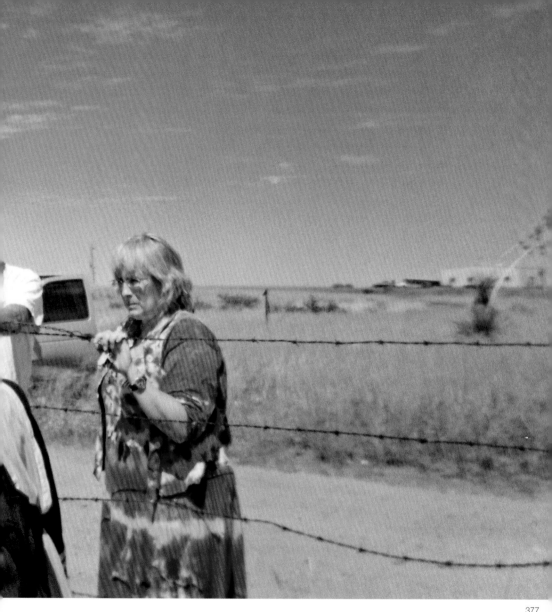

"There are twenty thousand Iowans that have lost their jobs in meatpacking, and it's all gone to illegals from Mexico. One guy said he was making $8 an hour, and they chucked him out. They paid an illegal minimum wage with no benefits."

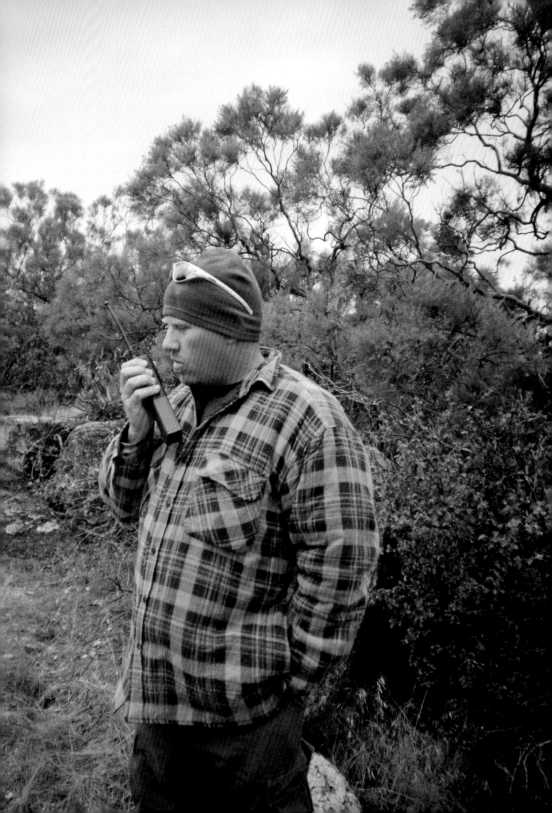

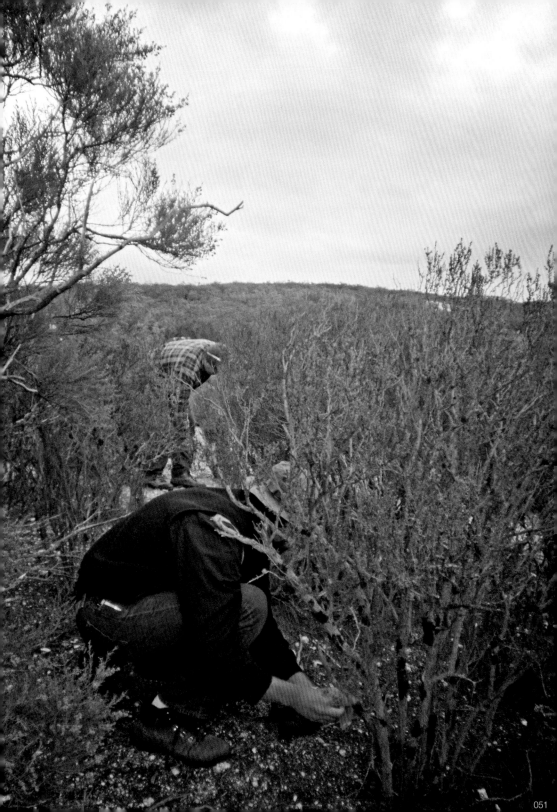

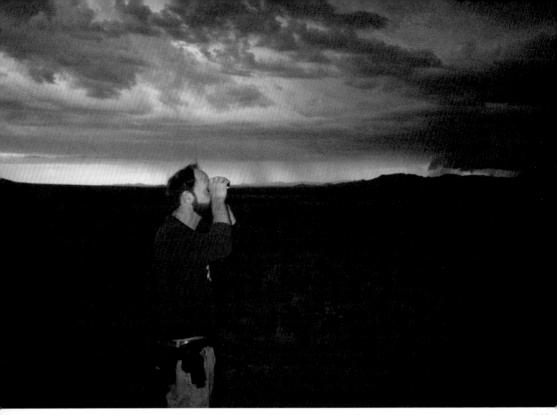

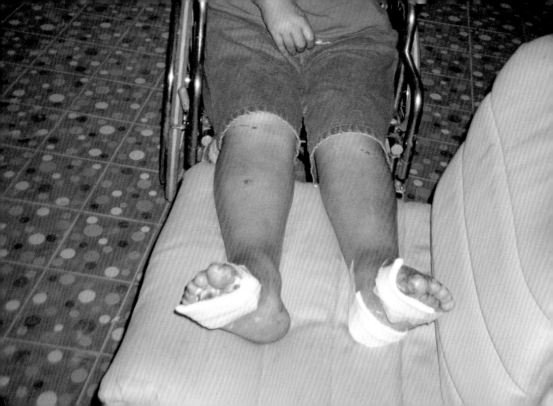

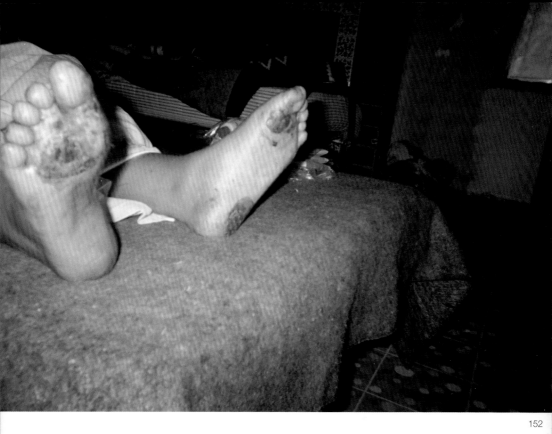

"I couldn't catch up with them, and I began to shout and cry. But only the mountains responded. Only the coyotes and other animals heard me."

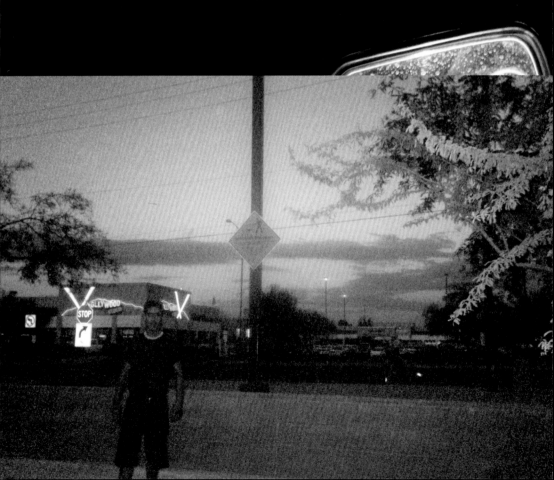

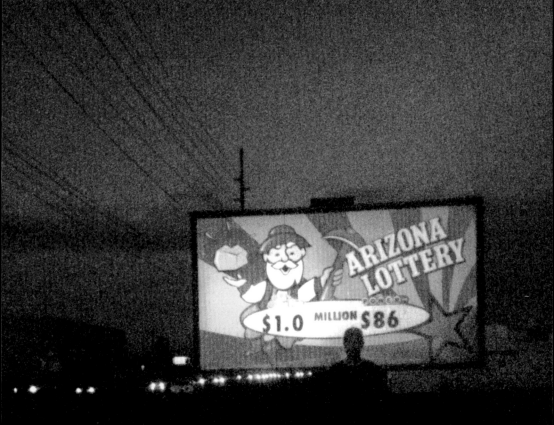

Border Film Project

**Photos by Migrants
& Minutemen on
the U.S.-Mexico Border**

**Rudy Adler
Victoria Criado
Brett Huneycutt**

Abrams, New York

The U.S.-Mexico Border

Each day, approximately three thousand Mexicans and Central Americans enter the United States illegally by walking across the southwestern border.

Their journey is expensive and often treacherous. Migrants typically pay $2,000 to $6,000 to *coyotes* to be smuggled into the country, and they risk dehydration and over-exposure on the multiple-day trek through the desert and mountains. Some four hundred migrants have been found dead along the border in each of the last five years.

Migrants come to the United States for many different reasons, but most boil down to simple economics. Mexicans and Central Americans employed at the minimum wage earn about $5 *per day* in their home countries; subsistence farmers must survive on less. Meanwhile, jobs in the United States—in construction, agriculture, meatpacking, domestic service, and restaurants and hotels—are readily available and pay a relatively lucrative $7 to $10 *per hour*.

A large immigrant population has both benefits and costs. Cheap labor means lower prices for goods and services—a benefit for all Americans. The costs, however, are shared unequally. Low-skill laborers in the U.S. suffer the most because they must compete for jobs with illegal immigrants who are willing to work for lower wages.

The federal government has moved ploddingly during the last fifteen years to deal with the growing wave of illegal immigrants. In the early 1990s, the U.S. Border Patrol (now part of the Department of Homeland Security) instituted Operation Hold the Line in Texas and Operation Gatekeeper in California to ramp up enforcement efforts along the

border. High-tech walls and thousands of new Border Patrol agents have fortified the urban borders and virtually eliminated migrant traffic in once-important crossing points like El Paso and San Diego. However, these measures have failed to reduce the total number of migrants coming across. They have instead redirected the flow to the deserts and mountains of Arizona and New Mexico. Now, an estimated eleven to twelve million undocumented migrants—some eight million of whom are from Latin America—reside illegally in the United States.

Everyone agrees that U.S. border and immigration policies aren't working and must be reformed. The details of such reform, however, remain up for debate.

Opinions are wide-ranging, but converge on a few principal themes: national security, human rights, culture, and the economy. Some argue that our most important priority is national security, and they favor even greater enforcement— perhaps entailing a two-thousand-mile border fence or the permanent deployment of the National Guard on the porous border. Others believe that for economic or humanitarian reasons, a guest-worker program is needed to bring more Mexicans and Central Americans to the country legally. Not wanting to ostracize proponents of either major view, lawmakers have failed to adopt effective immigration reforms.

For more information, please consult:

Hanson, Gordon H. "Illegal Migration from Mexico to the United States." *Journal of Economic Literature*, 2007.
Passel, Jeffrey S. "Estimates of the Size and Characteristics of the Undocumented Population." Pew Hispanic Center, 2005.

Project Background

We are three friends who gathered in the summer of 2005
to find an innovative way to shed light on the issue of illegal
immigration. After several weeks of filming and traveling on
both sides of the U.S.-Mexico border, we came up with an
idea—a way to document the border through the eyes of the
men and women on the line.

To recruit migrant photographers, we visited migrant shelters
and other humanitarian organizations on the Mexican side of
the border. In the busiest areas, these shelters house doz-
ens of migrants every night, providing them dinner, a place
to sleep, and sometimes clothes and medicine for the jour-
ney. We met the migrants in groups and told them about the
project. Since many had never used cameras before, we also
became impromptu photography teachers—pointing out the
flash and film wheel and teaching them how to aim through
the viewfinder. In addition, we showed them what U.S. mail-
boxes look like so they would know how to return the cam-
eras to us. Most migrants seemed eager to participate. Many
expressed a profound desire to show American citizens what
they had to endure to arrive in the United States.

We distributed cameras to Minutemen volunteers at obser-
vation sites in Arizona, New Mexico, Texas, and California.
During observations, volunteers camp out from sunset to
sunrise, silently staring into the pitch-black darkness of the
desert. When they spot migrants and smugglers, they avoid
direct confrontation and instead call the Border Patrol. Our
time with the Minutemen gave us a view of the so-called
"vigilantes" that was much more nuanced than the carica-
tures painted by the media. We realized that volunteers are

by and large concerned Americans, trying to do their part to make the United States a safer place and to protect American jobs. Many are retired veterans or have backgrounds in law enforcement. They have continued their lives of public service by volunteering to do what they believe the U.S. government should be doing—regaining control of the U.S. border with Mexico.

To date, we have received seventy-three cameras—thirty-eight from migrants and thirty-five from Minutemen—with nearly two thousand pictures in total. The pictures show the human face of immigration, and they challenge us to question our stereotypes and to see through new and personal lenses.

To give greater depth to the images, we have also included short quotes, selected from the dozens of interviews we conducted with migrants and Minutemen. Migrant quotes come from photographers about to cross the border, other migrants already living in the United States, and relatives of migrants in El Salvador and Mexico. Minutemen quotes come from volunteers on border observations, as well as Minutemen leaders in Washington, D.C.

Migrants and Minutemen have very different backgrounds, yet they share one profound belief: at the end of the day, both sides would agree that they are documenting a situation that should not be happening. U.S. border policy is broken and needs to be fixed.

Camera-package Anatomy

Envelope:
Pre-addressed 4 x 8" envelopes with $1.60 in U.S. postage.
Collected at a post-office box in Arizona.

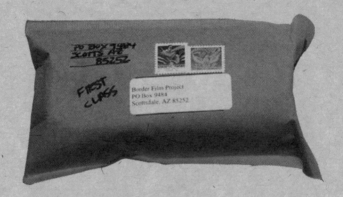

Gift card:
We wanted to thank the migrants and give them an incentive
to participate, and also allow them to remain anonymous. We
gave them gift cards that had a $0 balance from Wal-Mart.
When migrants returned their cameras to us, we added dona-
tions to their cards. Minutemen received Shell gas cards when
they returned their cameras.

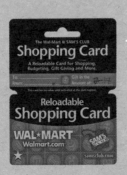

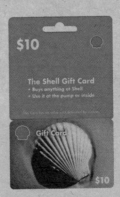

Disposable camera:
With flash, twenty-seven pictures, and 400 ISO film.

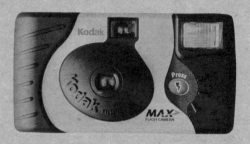

Index card:
Description of the project, basic photography instructions, and an optional space for personal information (first name, age, etc.). Migrants also received images of U.S. mailboxes so they knew where to drop off cameras.

- Utilice el flash para todas las fotos, día y noche.
- Si hay poca luz, el flash alcanza sólo 2 metros.
- Para fotos de personas u objetos, saque fotos de 1 a 3 metros.
- No tape el lente con el dedo.
- No saque fotos de la patrulla fronteriza ni ningún policía.

Please complete the following before returning.

NAME: _____ AGE: _____

ADDRESS: _____

PHONE: _____

EMAIL: _____

HOMETOWN: _____

OBSERVATION SITE: _____

_____ SEND ME A COPY OF MY PICTURES (SUPPLY EMAIL ADDRESS ABOVE)

_____ YOU CAN DISPLAY MY FIRST NAME, AGE, AND HOMETOWN

Distribution Points

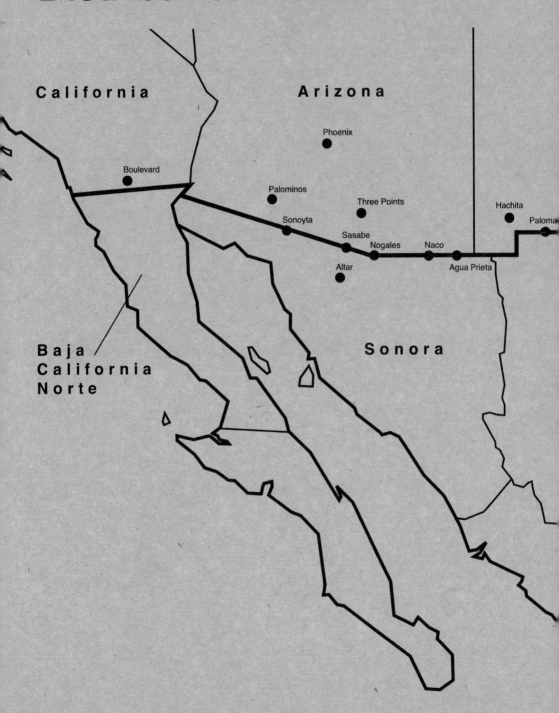

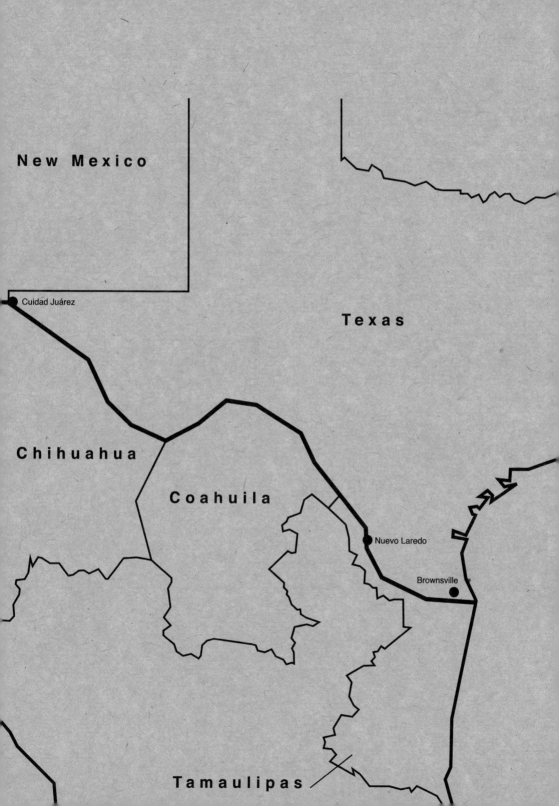

New Mexico

Texas

Cuidad Juárez

Chihuahua

Coahuila

Nuevo Laredo

Brownsville

Tamaulipas

Camera/Photographer Information

Cameras were assigned numbers when they were distributed. Photos throughout the book are identified by those numbers, which correspond to the details on the following pages.

Minutemen

Camera	Distribution site	Name, age	Notes
004	Naco, AZ	Robert, 70	Three Points sector chief.
006	Hachita, NM	Geo, 71	
007	Hachita, NM	Geo, 71	
008	Hachita, NM	Anonymous, 28	
009	Hachita, NM	Anonymous	
010	Hachita, NM	Wayne, 55	
011	Hachita, NM	Sherry, old enough	
015	Hachita, NM	William, 67	
016	Mission, TX	Anonymous	
024	Mission, TX	Linda, 49	
032	Three Points, AZ	Anonymous	
035	Three Points, AZ	Anonymous	
049	Boulevard, CA	Anonymous	
051	Boulevard, CA	Tim, 39	
053	Boulevard, CA	Dottie, 66	Nickname: Vigil Annie.
065	Palominos, AZ	Anonymous	
069	Palominos, AZ	Anonymous	Photographed construction of Minuteman border fence.
070	Three Points, AZ	Anonymous	
071	Three Points, AZ	Anonymous	

Camera	Distribution site	Name, age	Notes
072	Three Points, AZ	Jack, 59	
073	Three Points, AZ	Anonymous	
074	Three Points, AZ	Bob	Drove from Bloomingdale, IL, to volunteer.
075	Three Points, AZ	Michael, 56	Drove from Greybull, WY, to volunteer.
076	Three Points, AZ	Frank, 60	
079	Palominos, AZ	Anonymous	
080	Boulevard, CA	Rick	
081	Boulevard, CA	Rick	Reported migrant on highway to Border Patrol and photographed the encounter.
082	Palominos, AZ	Linda, 50	
091	Palominos, AZ	Anonymous	Photographed construction of Minuteman border fence.
097	Palominos, AZ	Anonymous	Photographed construction of Minuteman border fence.
247	Three Points, AZ	Anonymous	
255	Three Points, AZ	Robert, 70	Three Points sector chief.
347	Palominos, AZ	Anonymous	

Camera/Photographer Information (cont)

Migrants

Camera	Distribution site	Name, age	Notes
103	Phoenix, AZ	Olga, 35	Migrated from Chihuahua. Lived in the U.S. for ten years.
110	Phoenix, AZ	Agustina	Migrated from Chihuahua. Lived in the U.S. for eight years.
121	Agua Prieta, Sonora	Anonymous	
134	Phoenix, AZ	Benni	Migrated from Sinaloa. Arrived December 2005.
143	Agua Prieta, Sonora	Carlos, 55	Migrated from Zacatecas. Traveling to Seattle.
145	Naco, Sonora	Anonymous	
152	Naco, Sonora	Anonymous	
165	Naco, Sonora	Anonymous	
169	Agua Prieta, Sonora	Juan Carlos, 29	Migrated from Honduras. Traveled from Agua Prieta through Arizona to Hoover Dam. Camera mailed from Las Vegas.
170	Naco, Sonora	Miguel, 30	Migrated from Tijuana.
177	Agua Prieta, Sonora	Juan, 27	Migrated from Acapulco. Injured during first crossing attempt and recuperated for one month at migrant shelter in Agua Prieta.
182	Naco, Sonora	Anonymous	
189	Naco, Sonora	Anonymous	
202	Agua Prieta, Sonora	Anonymous	
207	Naco, Sonora	Anonymous	
210	Naco, Sonora	Anonymous	
220	Naco, Sonora	Anonymous	
238	Agua Prieta, Sonora	Armando, 38, and Javier, 24	Migrated from Mexico City and Hermosillo. Crossed New Mexico desert on Christmas. Camera mailed from Deming.

Camera	Distribution site	Name, age	Notes
318	Sonoyta, Sonora	Eddi, Pedro, and Oscar	
322	Phoenix, AZ	Concepcion, 39	Migrated from Sinaloa.
330	Phoenix, AZ	Ricardo, 38	Migrated from Chihuahua.
332	Sonoyta, Sonora	Anonymous	
354	Agua Prieta, Sonora	Anonymous	
361	Naco, Sonora	Anonymous	
363	Naco, Sonora	Anonymous	
367	Naco, Sonora	Anonymous	
369	Naco, Sonora	Anonymous	
374	Naco, Sonora	Anonymous	
375	Naco, Sonora	Anonymous	
377	Naco, Sonora	Anonymous	
379	Naco, Sonora	Anonymous	
380	Naco, Sonora	Anonymous	
500	Agua Prieta, Sonora	Ernesto, 35	Lived in Arizona.
501	Cuidad Juárez, Chihuahua	Eduardo, 33	Migrated from Guatemala. Traveled from Ciudad Juarez, through New Mexico, Arizona, California, and Oregon. Photos were mailed from Georgia.
601	Agua Prieta, Sonora	Margarita, 22	Migrated from Mexico City with daughter.
602	Agua Prieta, Sonora	Anonymous	Traveled from Agua Prieta to Tucson.
606	Agua Prieta, Sonora	Anonymous	

Acknowledgments

We extend our warmest gratitude to the brave men and women, both migrants and Minutemen, who have photographed their lives and created this project.

Thank you to our loving and supportive families: David Adler, Beth Huneycutt, Adriana & Nestor Crant, Teri & Doug Tomblin, Antonio & Elisa Criado, Bill & Jackie Nopar, Tony & Beth Adler, Jacob Adler, Aaron Adler, Ashley Huneycutt & Andrew McAuslan, and Bob & Georgia Huneycutt.

We wish to thank the following friends and institutions for their generous financial contributions: Shayna Berkowitz & Phyllis Wiener, Kim Lund, Stephen Cayer, Tempe Camera, Rick Jones, the New College MCR (Oxford University), Boston College's Salmanowitz Program, the Jesuit Community of Brophy Prep, Kata Bags, Yesenia Mejia, Gavin Cutler, Katie Johnson, Kara Keating, John & Rita Linehan, Robert Schiff, Matt Breaux, Sergio Padilla, Jr., Phillip Glover, Melissa Kramer, Janna Rudler, Mia Cohen, Click Caldwell, Alan Thomas Payne, LTA, Katie Staab, Lauren Hammer, Rita Braun, Noemy Lopez, Roberta Hopkins, and our many web donors.

For their invaluable help, a thousand thanks also go to: Sharky & Magdalena, Raymundo & Julieta, Francisco Garcia, Ernesto, the Scalabrini Casas del Migrante (Ciudad Juarez & Laredo), Stacey O'Connell, Jim Wade, Chris Simcox, Bob Wright, Al Garza, Tim Donnelly, Darrell Goodwin, Malia Politzer, Siti Cheng & Dave Eschrich, Cristina Estrada, Tim & Claire Broyles, Border Patrol (Nogales & Tucson), Agent Jim Hawkins, Tommy Bassett, Cecile Lumer, Katie Gigliotti, Michael Nowakowski & Radio Campesina, Lora Villasenor & Shirley Gunther, Creighton University, Regis University, Daniel Gonzalez, Sara Ines Calderon, Bryan Cox, Elizabeth Kistin, Wieden + Kennedy, Jelly Helm, Bekah Sirrine, Robert Kendall, David Myhre, Katharine Andrade, Jeff Moran, Scottsdale Museum of Contemporary Art, Luis Ibarra & Teresa Rosano, DiverseWorks, New York University, Rick Broadhead, *GOOD Magazine*, American Apparel, John Panther & Comisión Nacional de Derechos Humanos, William Howard, Craig Charland, Elizabeth Block, Katie Zwolak, Claudia Perez de Castillo, Deborah Susser, Eric Johnson, Jay Zimner, Jeff Selis, Kirk Iverson, Margaret Ford Barber, Deborah Aaronson, Laura Tam, Walter de la Vega, and karlssonwilker inc.

Thank you. Without your help, this project would not have been possible.

Editor: Deborah Aaronson
Designer: karlssonwilker inc.

Library of Congress Cataloging-in-Publication Data

Adler, Rudy.
 Border film project : photos by migrants & minutemen on the U.S.-Mexico border / Rudy Adler, Victoria Criado, Brett
Huneycutt.
 p. cm.
 Includes bibliographical references.
 ISBN 13: 978-0-8109-9315-0
 ISBN 10: 0-8109-9315-5
 1. Mexican-American Border Region—Pictorial works. 2. Immigrants—Mexican-American Border Region—Pictorial
works. 3. Illegal aliens—Mexican-American Border Region—Pictorial works. 4. Mexicans—Mexican-American Border
Region—Pictorial works. 5. Central Americans—Mexican-American Border Region—Pictorial works. 6. United States—
Emigration and immigration—Pictorial works. 7. Mexico—Emigration and immigration—Pictorial works. 8. Immigrants—
Mexican-American Border Region—Quotations. 9. Political activists—Mexican-American Border Region—Quotations.
10. Mexican-American Border Region—Biography—Miscellanea. I. Criado, Victoria. II. Huneycutt, Brett. III. Title.

 F787.A34 2007
 304.873072—dc22
 2006033263

Printed and bound in China
10 9 8 7 6 5 4 3 2 1

HNA ▊▊▊▊▊
harry n. abrams, inc.
a subsidiary of La Martinière Groupe

115 West 18th Street
New York, NY 10011
www.hnabooks.com

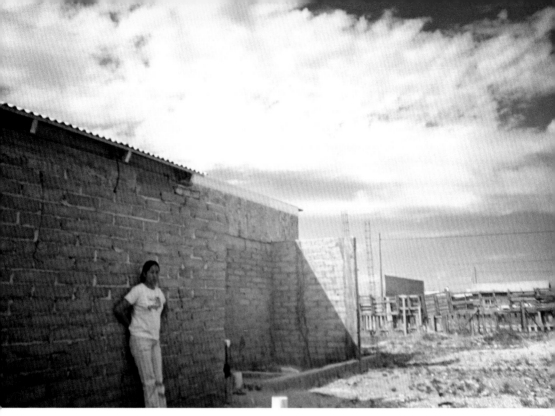

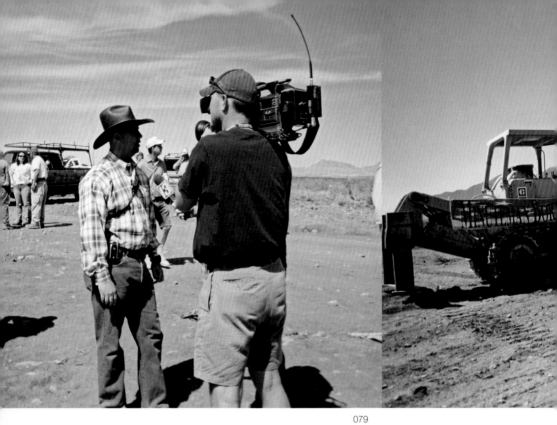

079

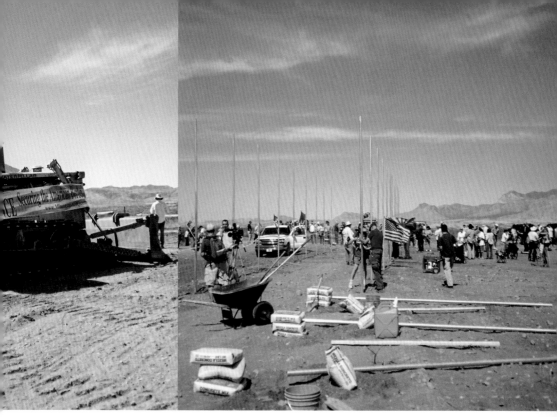

"I work tirelessly to help people focus their anger and frustration on Washington, D.C., not on the people who come across the border."

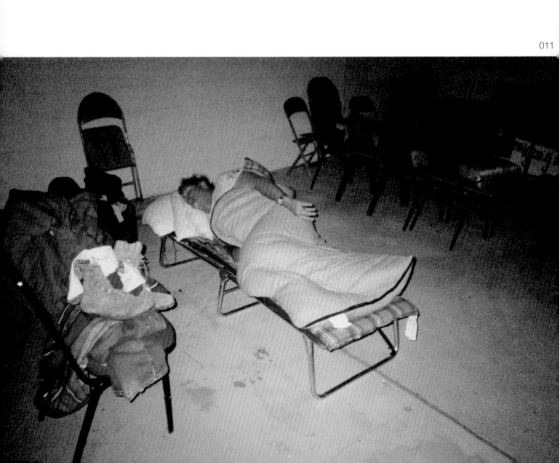

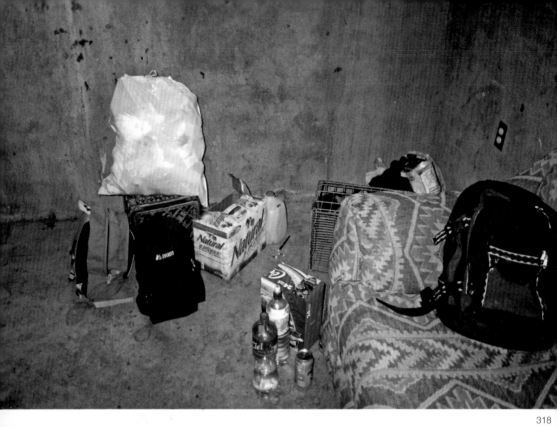

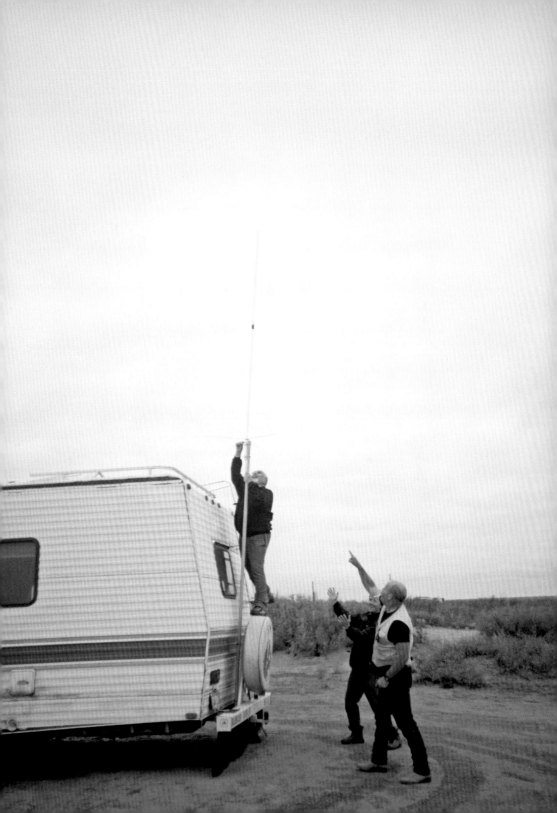

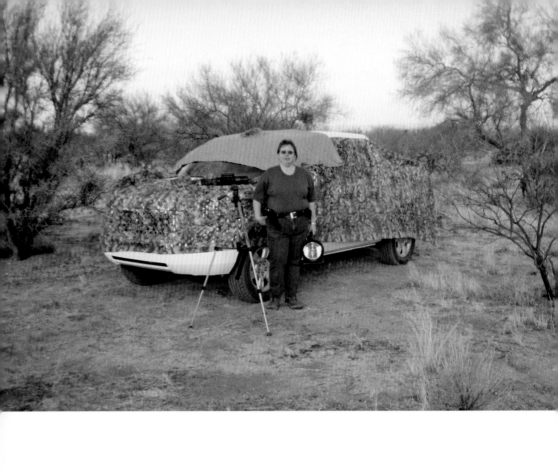

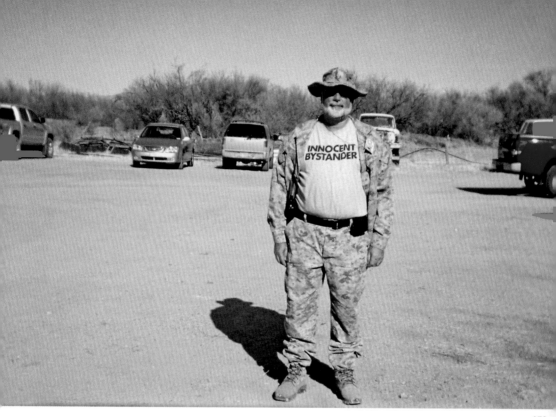

"It's a political protest, like marching and holding signs. We're putting boots on the ground. In order to achieve change, you have to get out and do something. Writing letters and calling your congressional reps don't seem to work anymore."

"I found the body. There was a water drum within a thousand feet of her. Her momma and daddy will never know what happened to her."

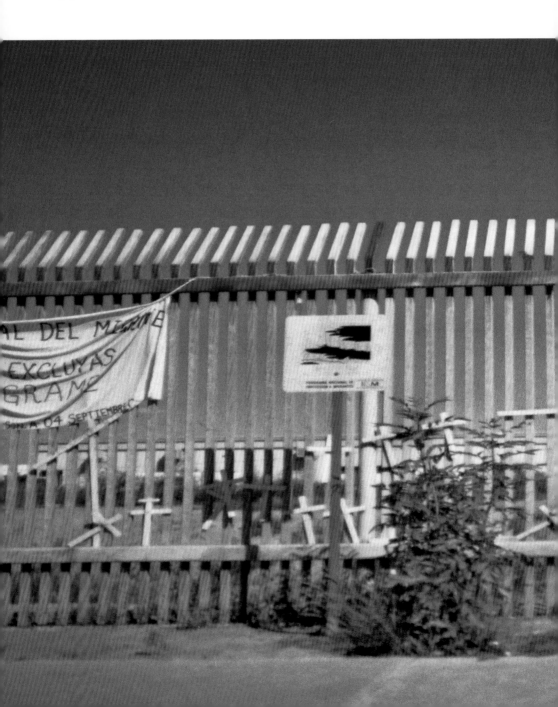

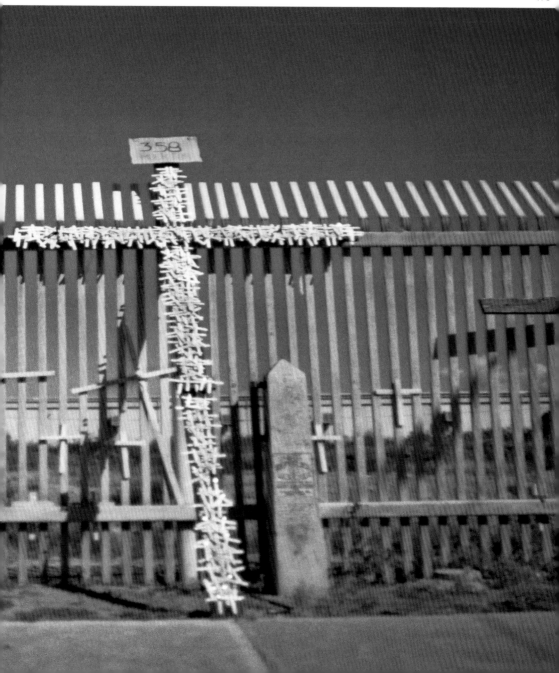

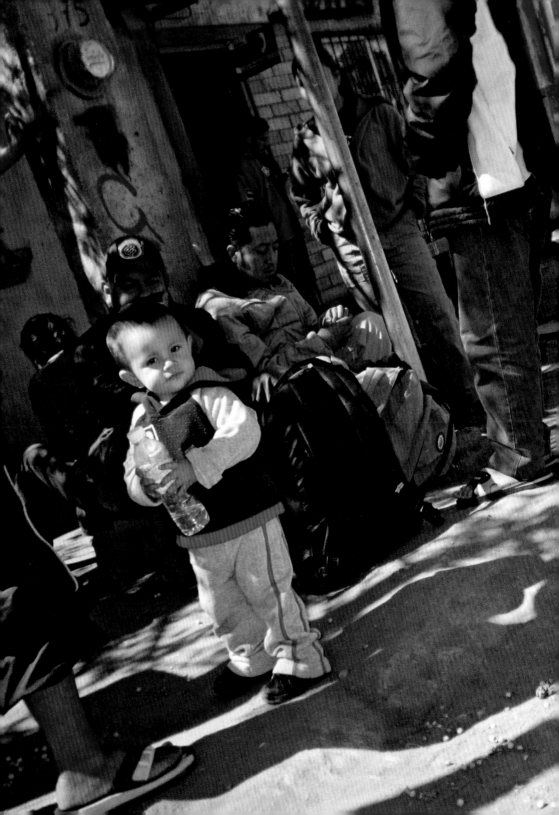

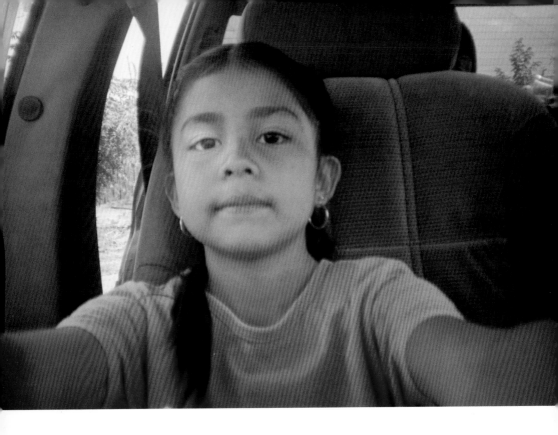

"My husband feels lonely. It's hard for him to get used to life in the United States. He tells me, 'I have missed the best years of my children's lives.'"

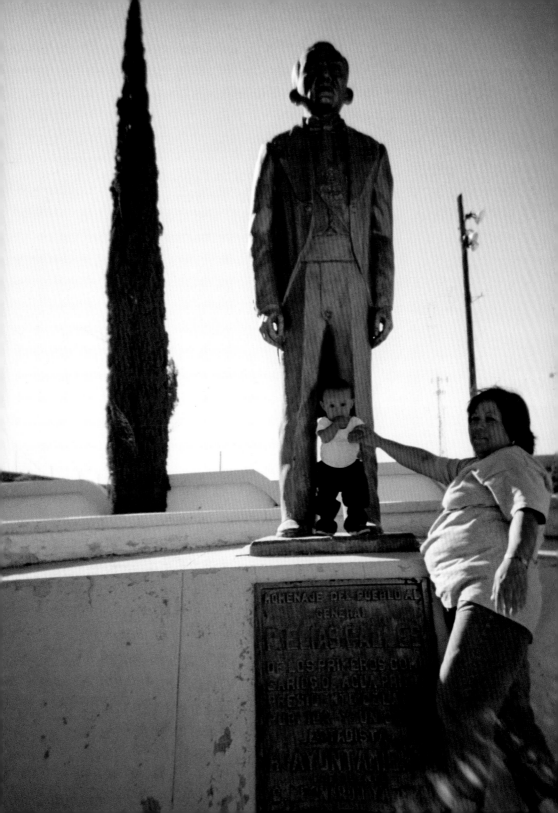

"I served my country when it called in 1968. I was in Vietnam. I have a Purple Heart from Vietnam. I am a father, a grandfather, a dedicated husband, and that's why I'm here—to help to protect and preserve our democracy."

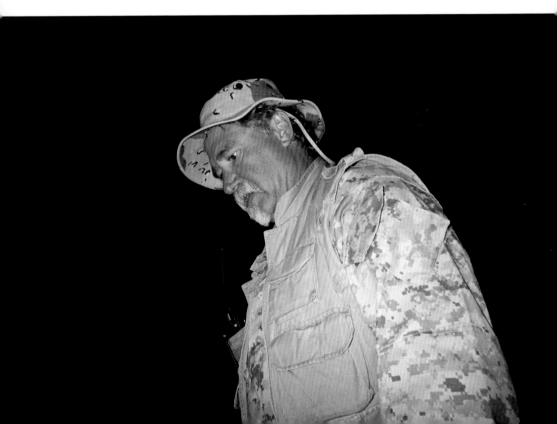

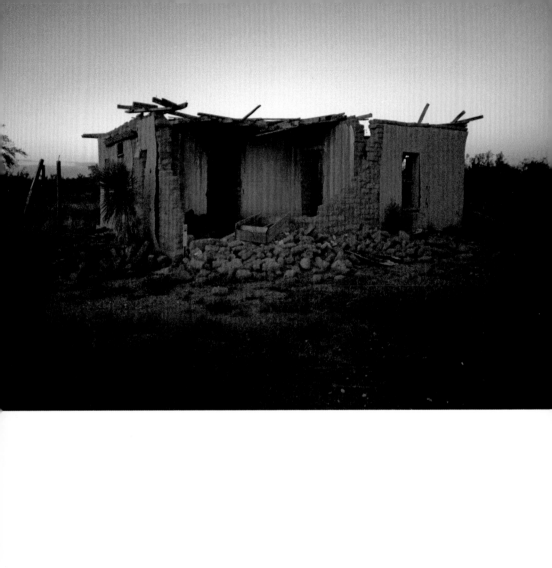

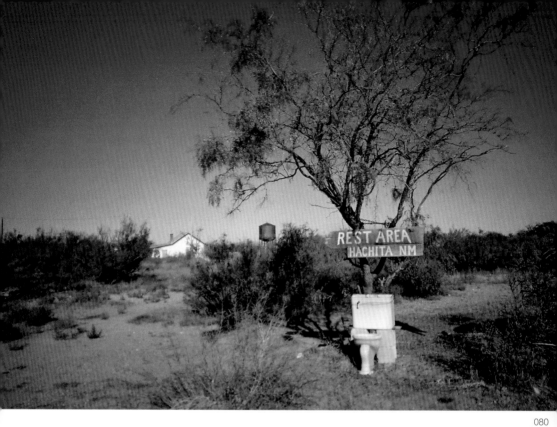

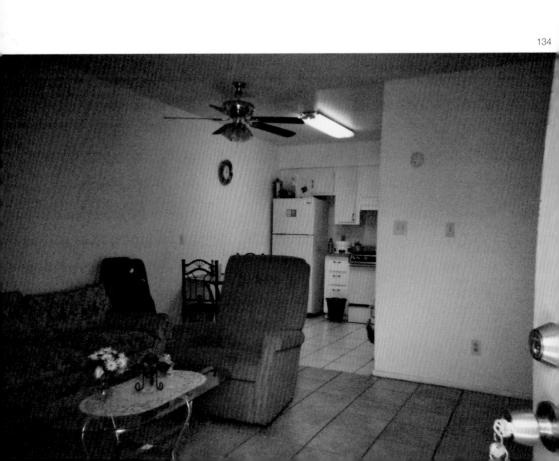

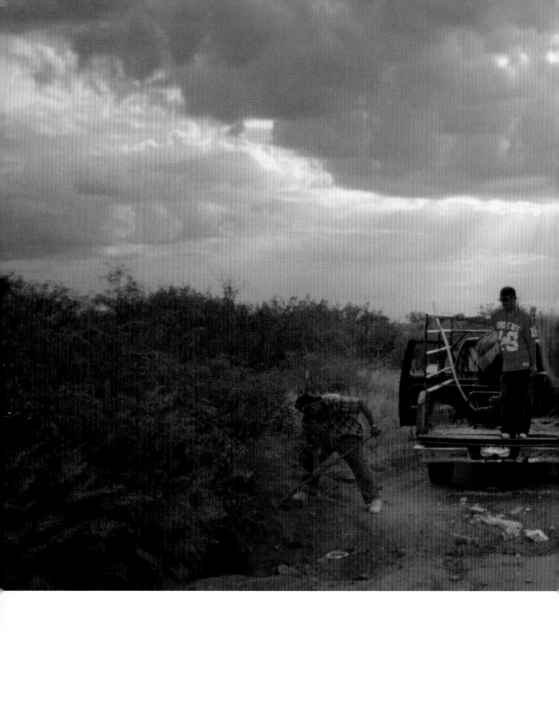

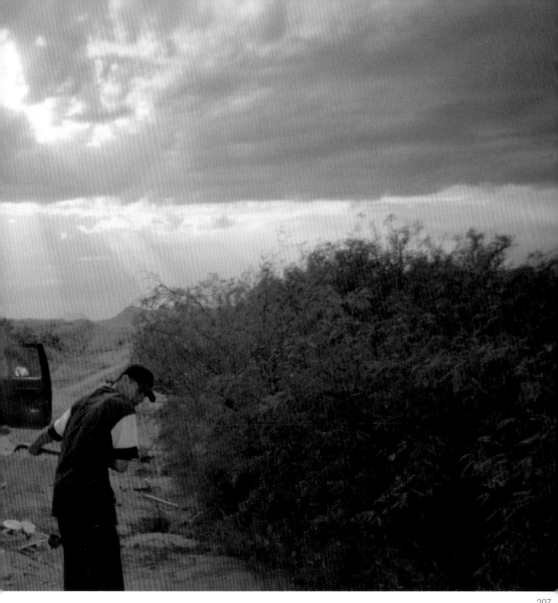

"I appreciate their situation because I think the Mexican government has not given them a fair shake. I think they have had many opportunities to improve their service to the poor people down there, and they haven't done it. The only thing I resent is the immigrants coming up here instead of trying to change things in their own country."

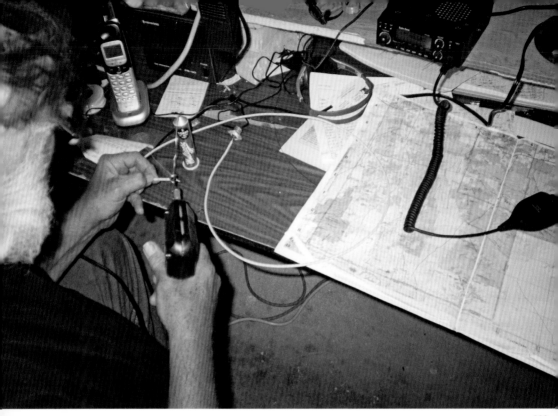

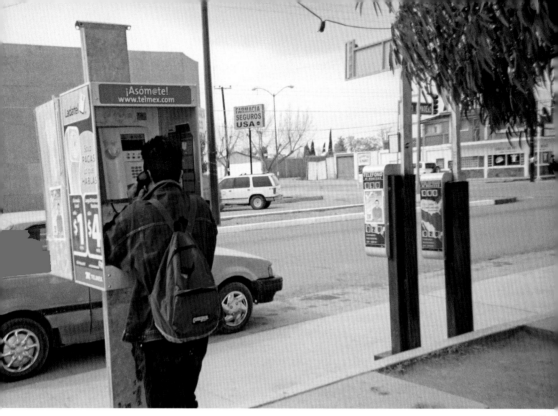

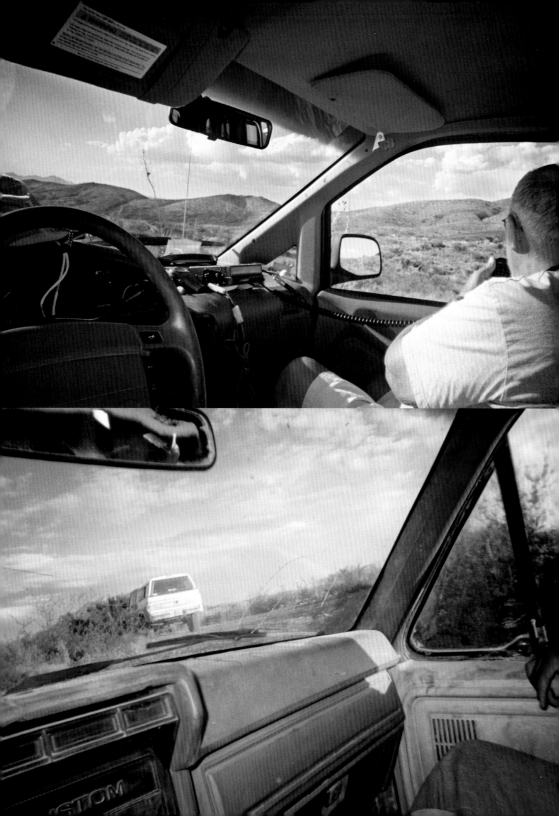

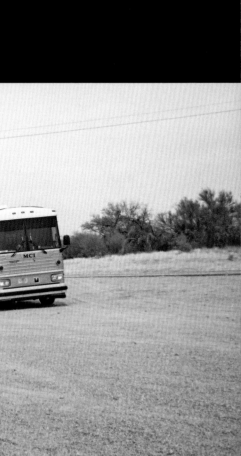

"If anyone wants to join us in our country, come through the front door and sign the guest book. We'll welcome you with open arms, but you've got to do it the right way. We have no knowledge if someone is a violent gang member or a fruit picker."

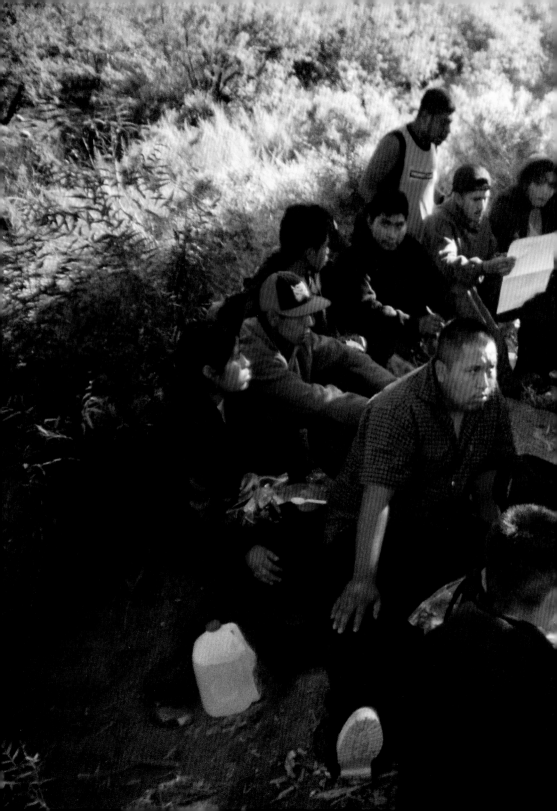

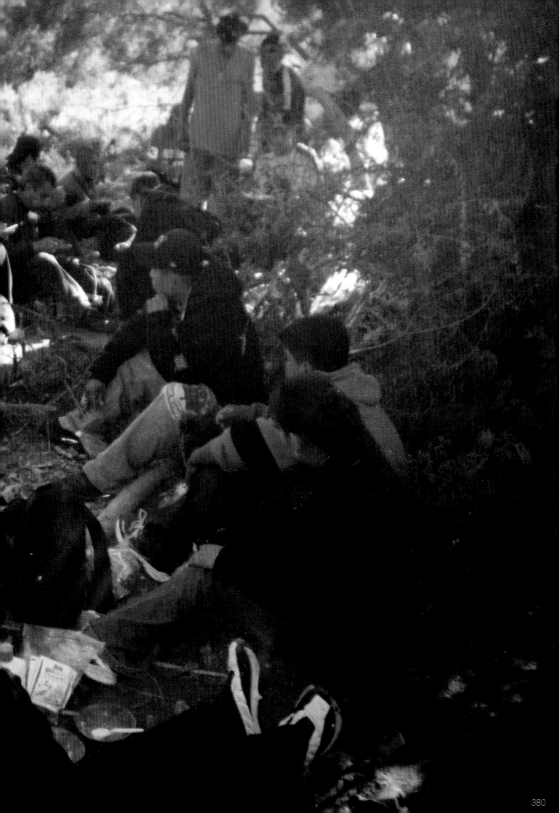

US GOV'T ONLY
EASEMENT

ALL PEOPLE MUST BE ON
BORDER ASSIGNED DUTY

ALL OTHERS
NO TRESPASSING

"The Department of Homeland Defense is a grotesque joke at best. You know if you've flown since the attacks of September 11th—you can't get a pair of fingernail clippers through airport security. They're checking backpacks now in the subways in New York. But every year, we have millions of people who breach our borders both north and south."

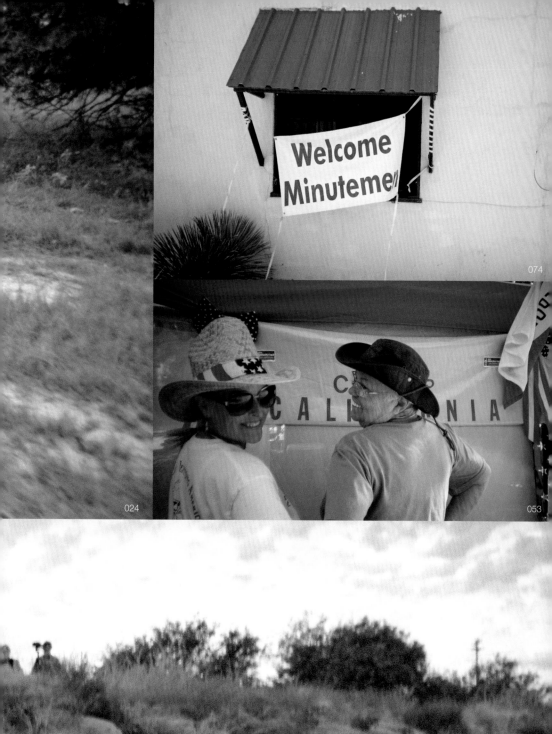

Welcome
Minutemen

074

CALIFORNIA

024 053

070

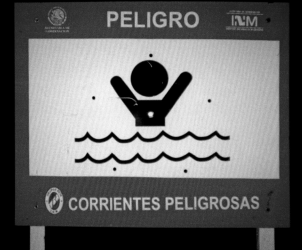

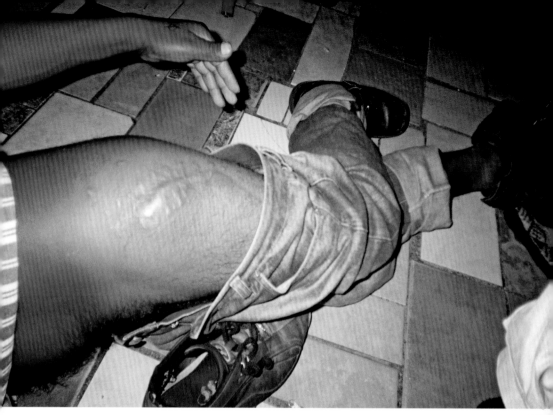

"We crossed the canal, and they picked us up on the other side in a pickup truck. The lights were turned off, and it was like two o'clock in the morning. The driver didn't see. There was a big boulder there. We hit it and flipped over."

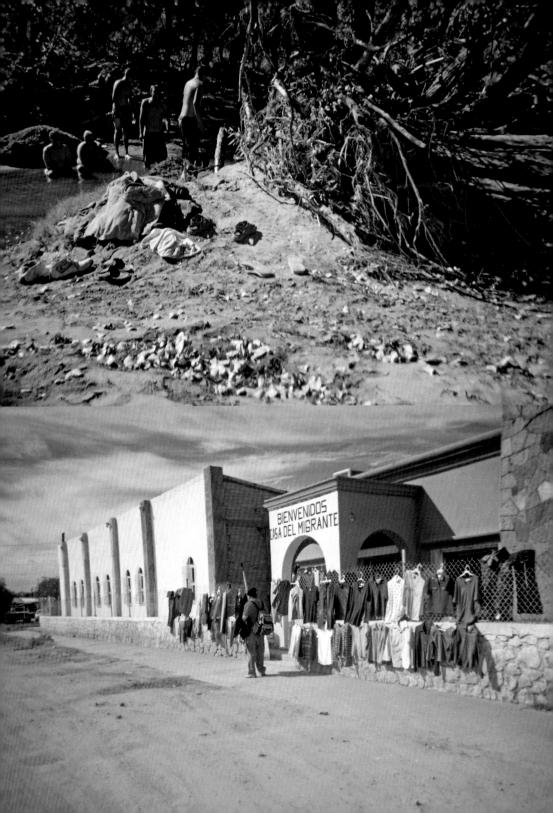

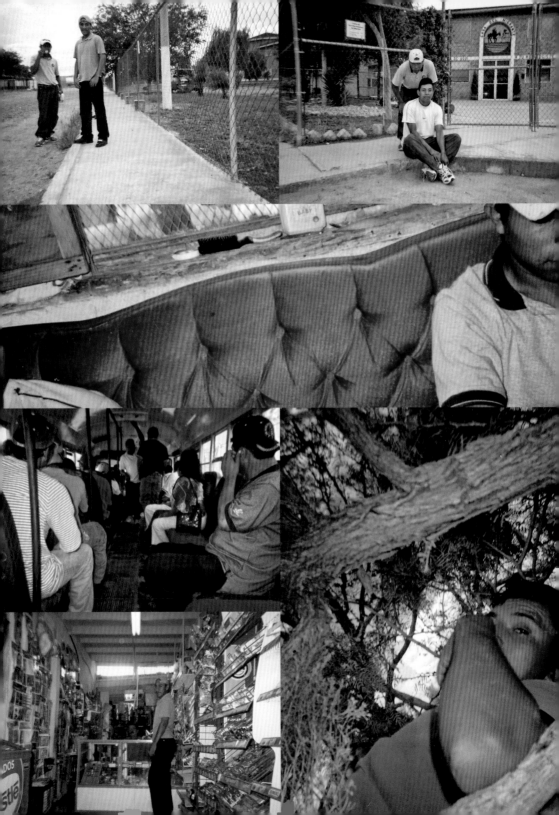

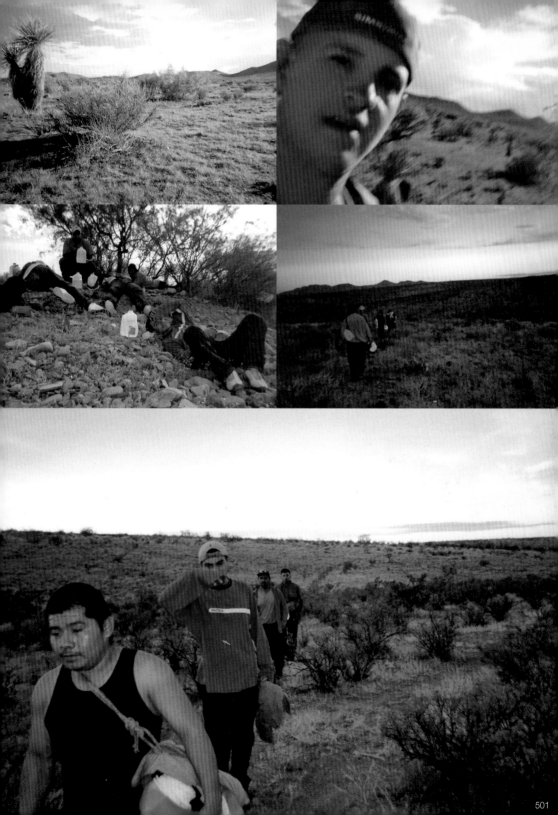

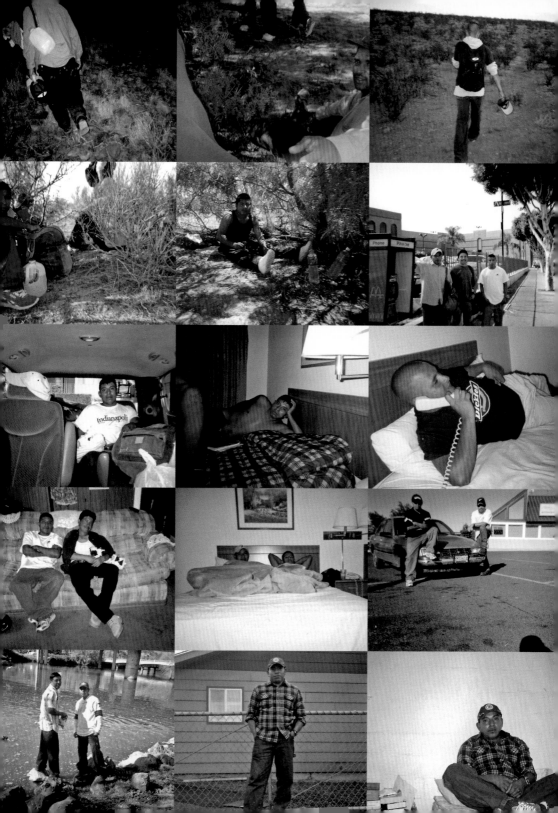

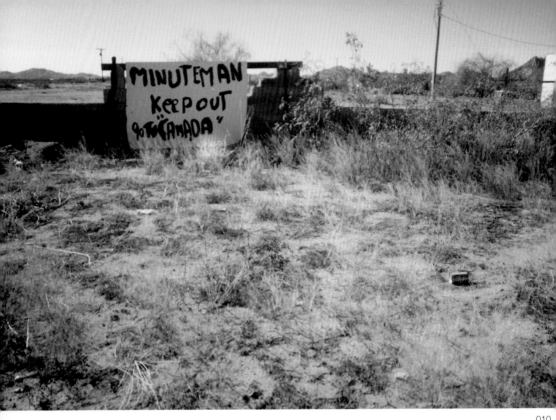

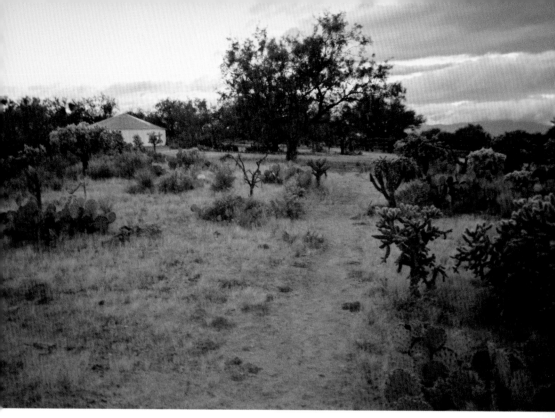

"It's scary to think that strangers are crossing through your backyard."

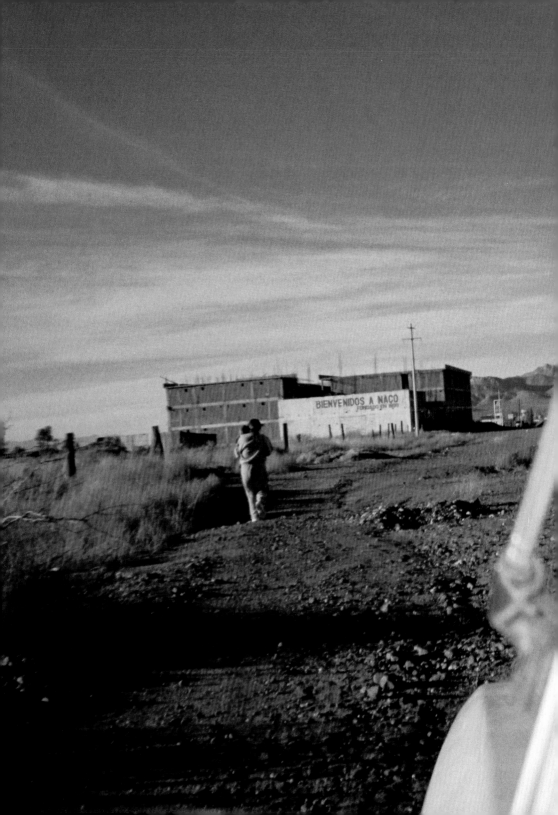

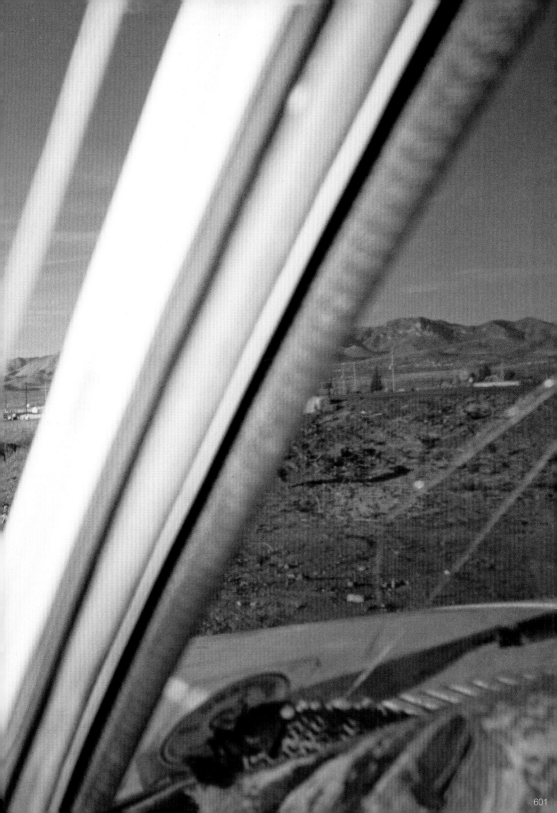

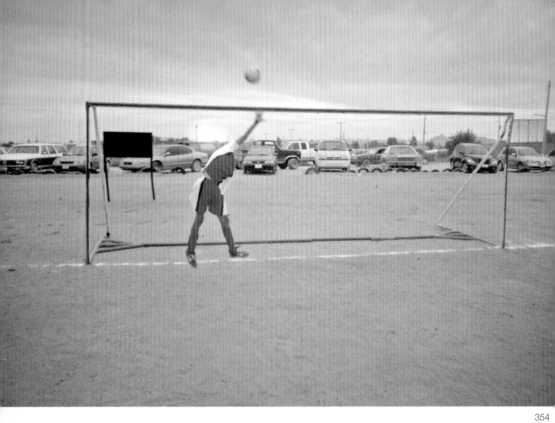

354

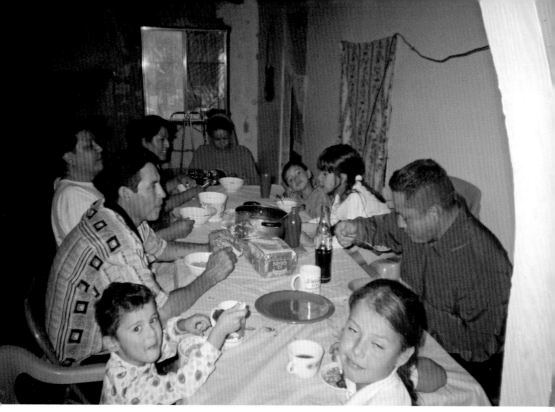

"Do you think people migrate to the United States to tear their families apart? It's that necessity. It's that hunger. Wouldn't I love to have my family here with me?"

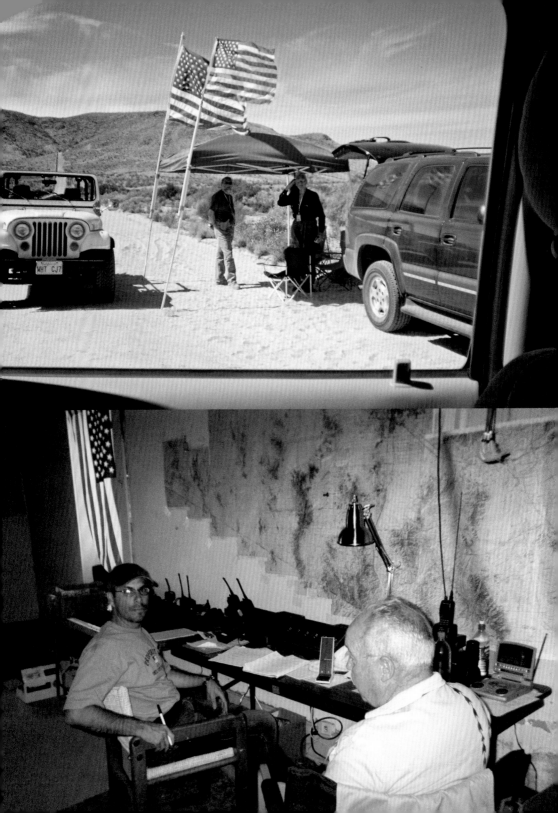

"The Minutemen do exactly what President Bush requested all citizens to do in his State of the Union speech. I don't know if anybody remembers his State of the Union speech seeing as how they are so forgettable. But here's what he said: 'I call on all Americans to be ever-vigilant, to report any unusual activity to the appropriate authority, and to stand ready to give aid to the appropriate authority when they do arrive on the scene.' Does anyone remember that? I do."

"I am not sure why we worry about the borders in Iraq, but we don't worry about them in our own country."

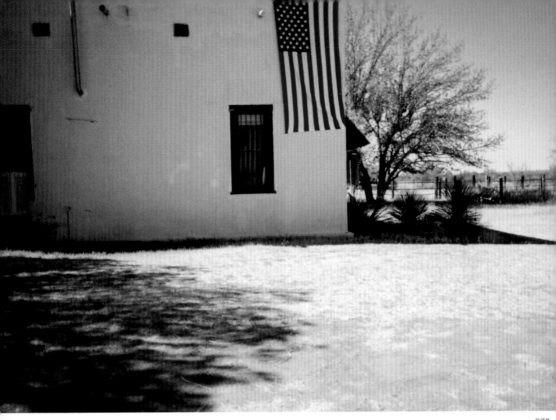

"I came to the States to earn a future. I worked and made a little money to return home and start my own business. It's *my own*."

"We do not give away the American Dream. This dream of liberty, this dream of freedom, this dream of a government run by 'We, the people.' That's the reason I'm here as a Minuteman—I want to keep that dream alive."

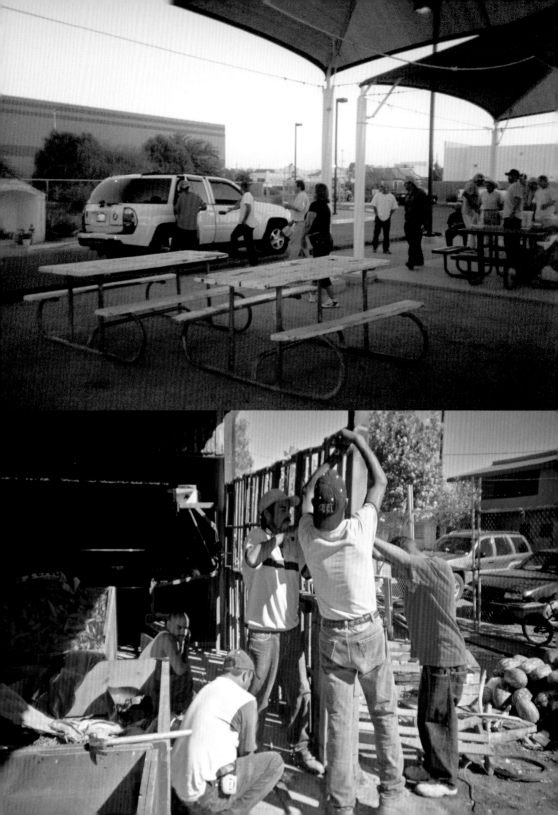

"I'm always thinking about my family. One more day of work means $100 more that I can earn and send them."

"Big business likes the cheap labor that comes across. They come to work for greedy Americans."

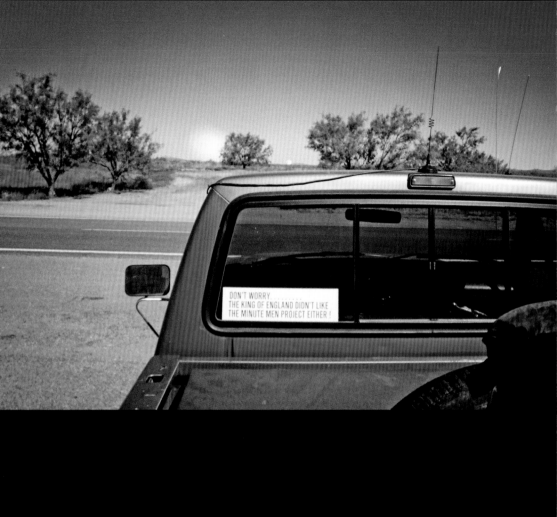

"Border Patrol came over to us and said, 'We just want to thank you. We appreciate everything you're doing. But please don't tell our supervisor that we said that.'"

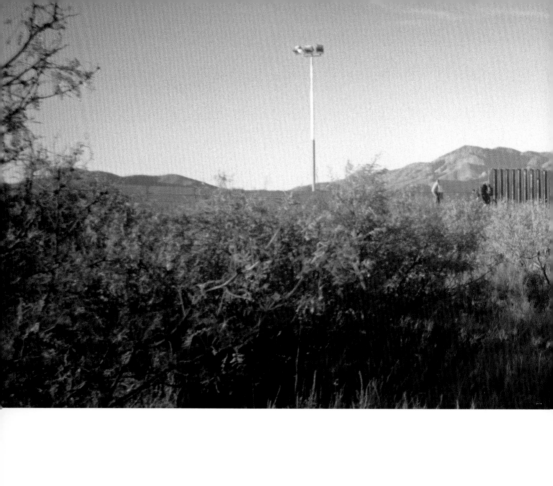

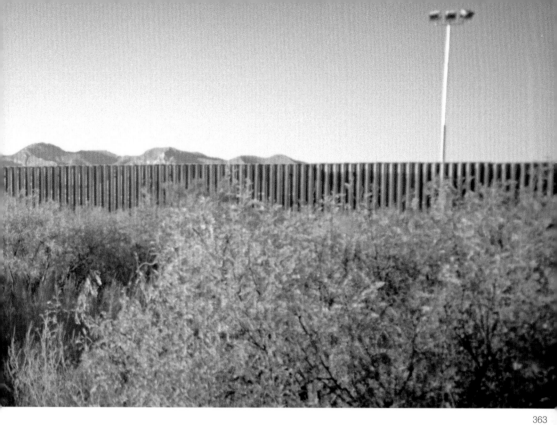

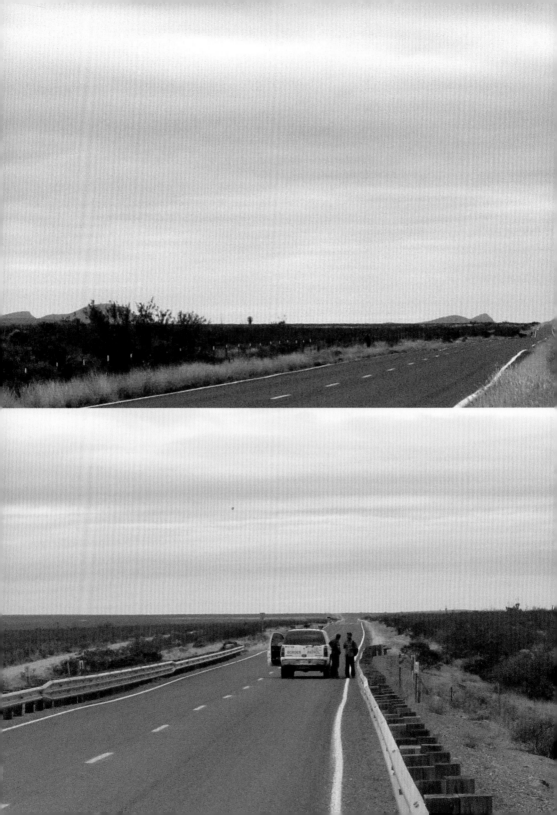

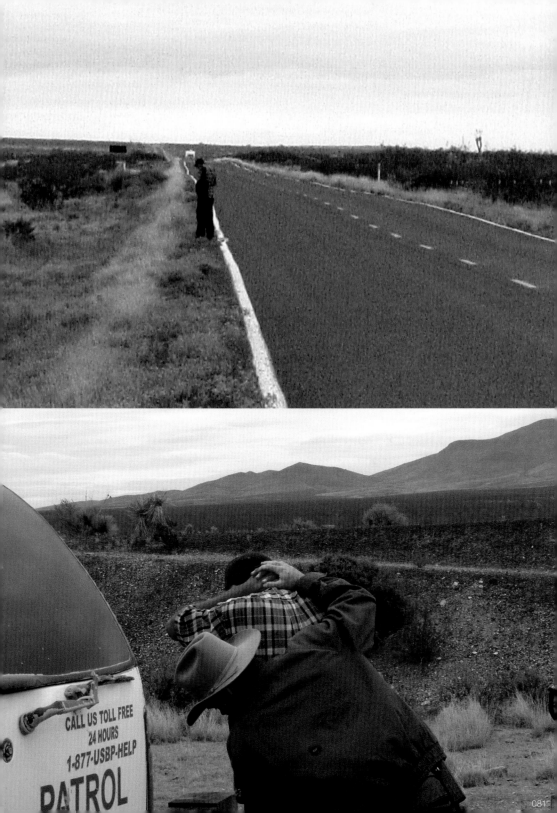

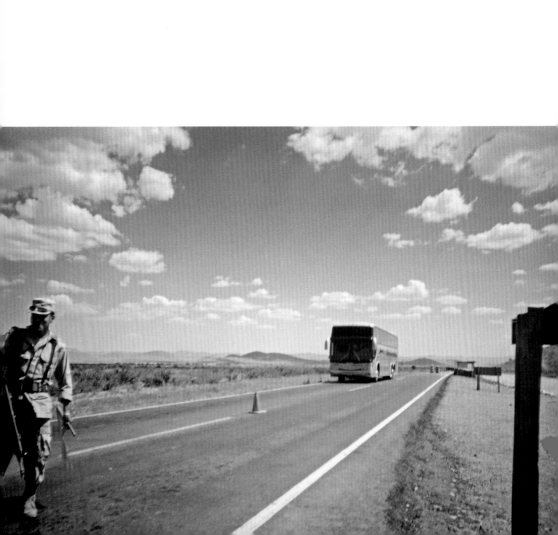

"We didn't succeed this time, but we will next year… This year the *gringo* harvests can go to waste. We would like to see the *gringos* gather their own harvests!"

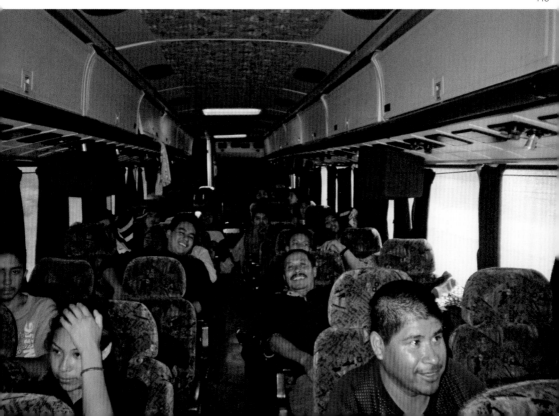

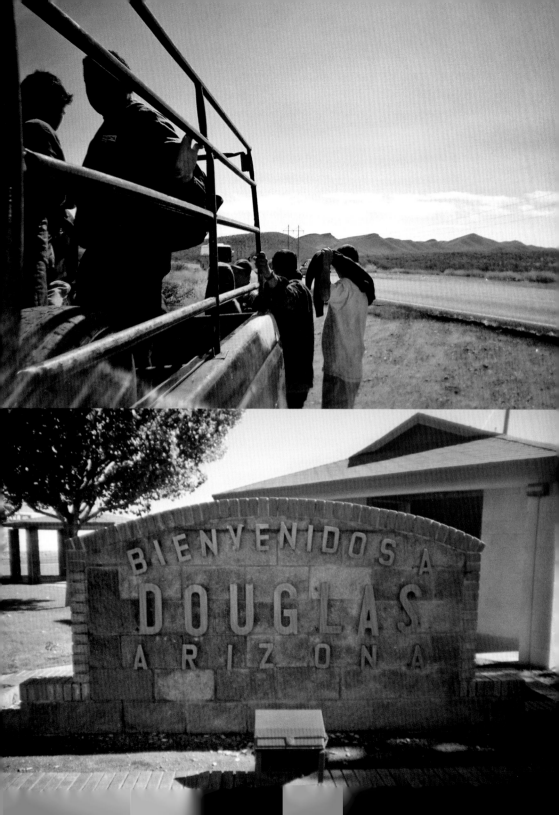

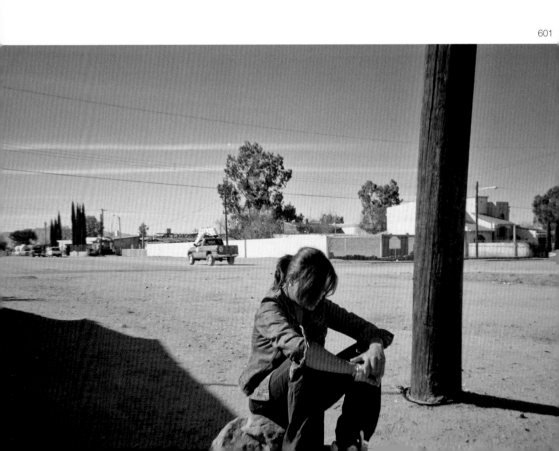

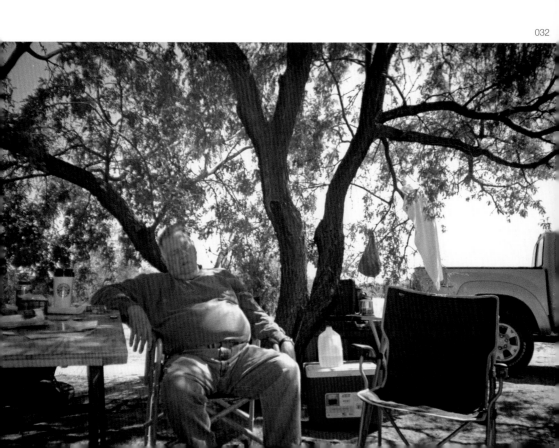

"You'll get bobble-headed on occasion because you're looking at the same view time after time after time. It gets old and your eyes start glazing over. So you stand up and do a couple of walk arounds. Change your seat... As quietly as possible, of course."

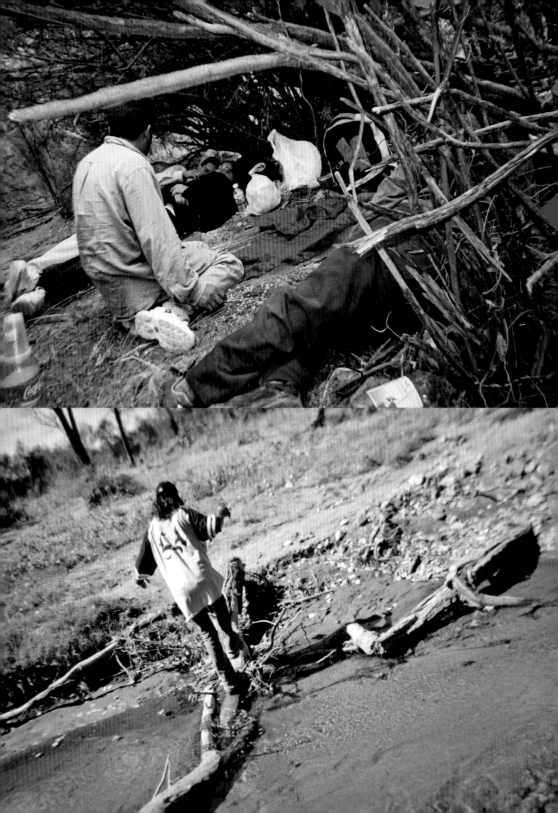

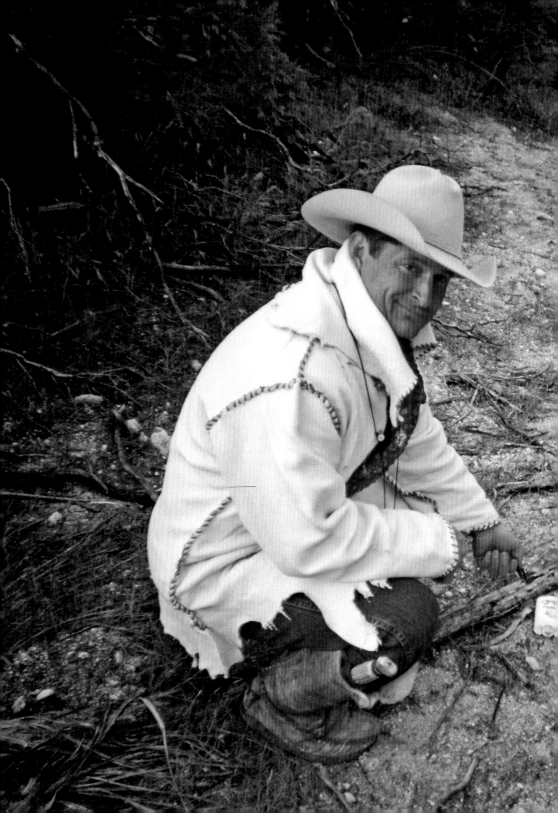

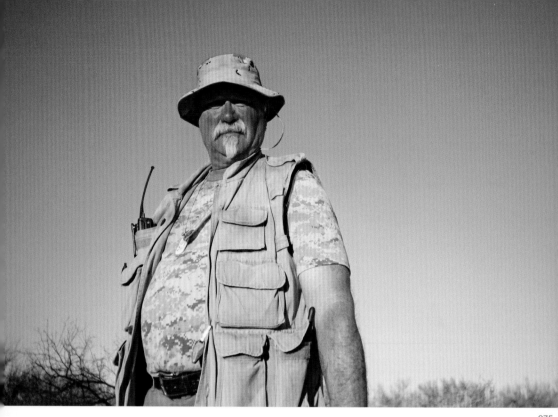

"This isn't about keeping someone from coming here to get work. There is a right and wrong. You enforce the laws. If it hurts your feelings, you know what I always say. Tough. It's the law. It's the way it is."

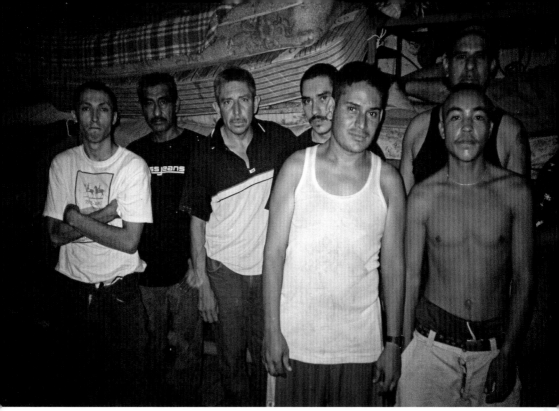

"As long as everything remains this way, we will keep crossing. If they throw out two by Nogales, ten will enter by Mexicali. And if they deport five by Juarez, seven will come through Laredo. If today they throw me out, tomorrow I'll come back."

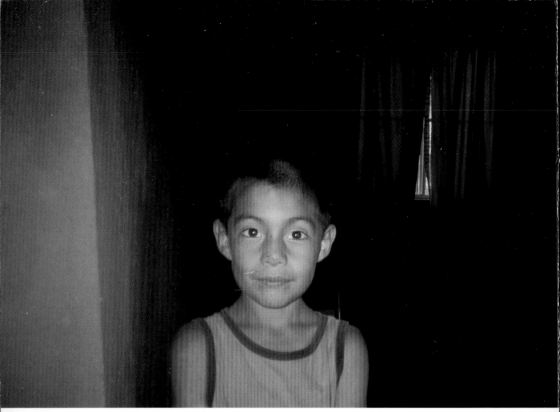